Monet

Monet

John House

Phaidon · Oxford

Phaidon Press Limited, Littlegate House, St Ebbe's Street, Oxford OX1 1SQ

First published 1977
This edition, revised and enlarged, first published 1981
© Phaidon Press 1981

British Library Cataloguing in Publication Data
Monet, Claude Oscar
 Monet. — 2nd ed.
 1. Monet, Claude Oscar
 I. House, John
 759.4 ND553.M7

 ISBN 0-7148-2162-4
 ISBN 0-7148-2160-8 Pbk

Typset, printed and bound in Singapore under co-ordination by
Graphic Consultants International Private Limited.

The publishers wish to thank all private owners, museums, galleries and other
institutions for permission to reproduce works in their collections. Further
acknowledgement is made to the following: Jorg P. Anders, Berlin, Fig. 17;
Country Life, Ltd., London, Fig. 11; Courtauld Institute, London, Fig. 26; John
R. Freeman, London, Figs. 18, 22; The Barnes Foundation, Merion, Penn., ©
photograph of Fig. 6; Photographie Bulloz, Paris, Fig. 32; Durand-Ruel, Paris,
Figs. 13, 46; H. Roger Viollet, Paris, Fig. 3; Cliché Vizzavona, Paris, Fig. 23.

Monet

When the paintings of the Impressionists first appeared publicly in the 1870s, they created an entirely new type of exhibition picture — small, informal in composition, freely and spontaneously painted, showing everyday scenes treated in clear bright colour. At the time, the Impressionist vision seemed unintelligible, the antithesis of art. Yet by the turn of the century, this way of painting had swept the western world, and the original masters of the movement in Paris had become rich and famous. Today, our ideas of landscape painting, and even the ways in which we see the world itself, are conditioned by the Impressionist vision, which we accept without question as a 'natural' way of seeing and representing our surroundings.

More than any other single artist, Claude Monet was the creator of this new idea of painting; his scenes of sailing boats at Argenteuil are synonymous with the popular idea of Impressionism (Plates 18, 20). But this type of painting is only one of the many facets of Monet's work; in a career of over sixty years, he pursued his basic aim with an originality and an intensity that rarely flagged. This aim he summarized in 1926, the year of his death, in terms he could have used at any time since the 1860s: 'I have always had a horror of theories; my only virtue is to have painted directly in front of nature, while trying to depict the impressions made on me by the most fleeting effects.' This central preoccupation led Monet through a sequence of experiments in which he continuously expanded his range of effects. It also forced him to explore with ever greater concentration a basic concern of all landscapists: to find ways of reconciling the perception of three dimensions with the demands of a two-dimensional canvas, to make a picture that is coherent in terms of coloured paint and brushstrokes out his of experiences of objects, distance and atmosphere. Monet's greatness as a landscapist lies in the completeness of the reconciliation which he achieved, in the ways in which he made the surface relationships within his paintings express the forms and forces of nature.

Claude Monet was born in Paris in 1840, but about five years later the family moved to Le Havre, where Monet's father was to work as a wholesale grocer. Monet's childhood at Le Havre, where the River Seine meets the sea, established his lifelong obsessions as an artist: he always lived by the Seine and found in the Seine valley most of his favourite motifs, and when he travelled he usually explored and painted the coast, particularly in Normandy. However, Monet did not immediately begin to sketch the natural scenes around him; his artistic beginnings were as a caricaturist: in his teens he earned his pocket-money by clever comic drawings of the people of Le Havre. His initiation into painting nature he

Fig. 1
Photograph of Monet Aged 20,
Taken by Carjat, 1860

always attributed to his meeting with the artist Eugène Boudin (1824–98), then little known and working in Le Havre; some time around 1857, Boudin took Monet with him one day when he went to paint in the countryside, and, Monet said later, 'it was as if a veil was torn from my eyes; I understood what painting could be.'

Thenceforth, landscape became his prime concern. In 1859, his caricatures paid for a trip to Paris, where he met Boudin's former teacher, the landscapist and animal-painter Constant Troyon (1810–65), and also made his first contacts with the Realist artists and writers in Paris; he saw but did not yet meet the high priest of Realist painting, Gustave Courbet (1819–77). Early in 1861, Monet drew an unlucky number in the lottery for military service and chose to go with the *Chasseurs d'Afrique* to Algeria, where, he later said, he received 'impressions of light and colour' which 'contained the germ of my future researches'.

However, after only a year he was back in France on sick leave, and his father agreed to buy him out of the remainder of his service, provided he would undergo a formal training as an artist with an established master in Paris. In the autumn of 1862 he entered the studio of the Neo-Classical painter Charles Gleyre (1806–74), where he continued to work, in a rather desultory fashion, probably until the spring of 1864.

During these years, though, his most important encounters were outside his academic studies, and it was these encounters that guided the development of his painting during the first years of his career as an independent artist. In the summer of 1862, he met the Dutch landscapist

Fig. 2
The Seine Estuary at Honfleur

OIL ON CANVAS, 90 x 150 CM. 1865. LOS ANGELES,
THE NORTON SIMON FOUNDATION

Johan Barthold Jongkind (1819–91) near Le Havre: 'From then on, he was my real master; to him I owed the final education of my eye.' Jongkind was the model for Monet's first seascapes of 1864, when the two men were together on the coast; Monet's two marines exhibited in 1865 (Plate 1 and Fig. 2), though much larger than Jongkind's contemporary canvases, are virtual tributes to the Dutchman's style in their fluent yet delicate handling, which suggests natural detail and the fall of light without resorting to dry and overprecise description.

These paintings were shown at the Salon — the French equivalent of the Royal Academy and main forum for conventional art — and were well received by the critics, a success that encouraged Monet to undertake a more ambitious enterprise; for this, though, he turned to a different inspiration. He decided to execute a vast picnic scene, on a canvas twenty feet long, which in scale and in the overt modernity of its grouping would outshine the *Déjeuner sur l' Herbe* by Edouard Manet (1832–83), which had caused such a sensation at the Salon des Refusés — a counter-Salon set up for artists refused by the Salon itself — in 1863. Since this *succès de scandale*, Manet and his work had become the rallying point for younger artists turning against the canons of the Salon, which favoured meticulous technique and subjects taken from history and mythology. Monet never completed his own *Déjeuner* to his satisfaction, and it survives only in fragments (Plate 2 and Fig. 3); in its bold emphatic brushwork it echoes Manet, but the informality of its composition and its sparkling light-effects are quite unlike the old-masterly grouping and studio lighting of Manet's picture. Paradoxically, though, when Monet abandoned the large version of his painting, he quickly executed for the Salon of 1866 a life-size portrait of his mistress Camille (Plate 3), which owed more to Manet than any of his other major paintings. This led Manet to utter bitter quips about Monet aping both his style and his name, but the two men seem to have met in 1866, and later became firm friends. During this period, too, Monet got to know Courbet, who became a strong supporter of his, though holding different ideas about the technique of painting: Courbet generally worked on a dark-toned canvas-priming, and built up his paint thickly towards the highlights, while Monet increasingly favoured a light-toned priming, which helped him to achieve the luminosity which he sought in his light-effects.

In Gleyre's studio, Monet had met three fellow-students with ideas congenial to his: Frédéric Bazille (1841–70), who quickly became a close comrade, Pierre-Auguste Renoir (1841–1919), and Alfred Sisley (1839–99); around 1860, he had first met Camille Pissarro (1830–1903). After the Franco-Prussian War of 1870–1, in which Bazille was killed, these friends were to become, with Monet, the nucleus of the Impressionist group; they were not so closely linked in the 1860s, but worked together on occasions and shared a number of interests. They were principally

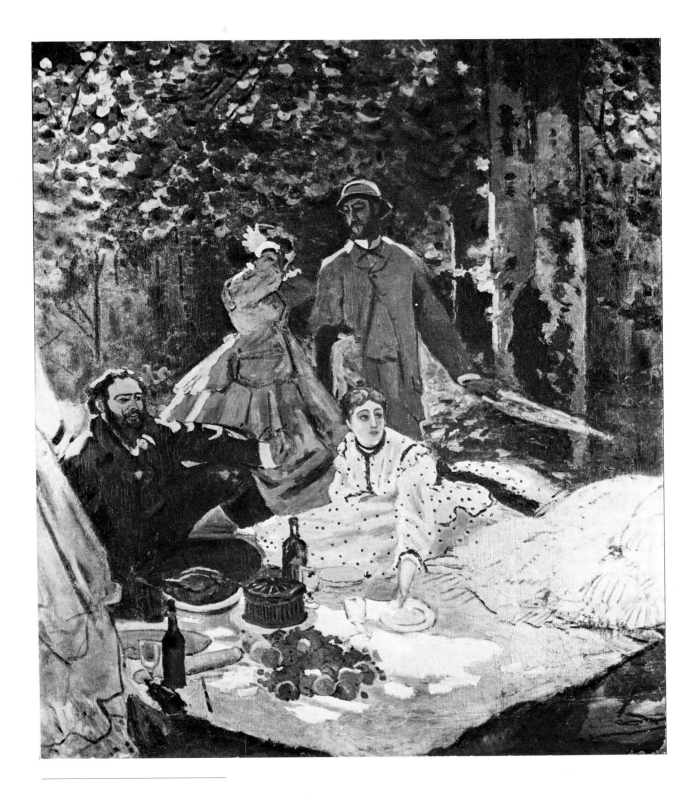

Fig. 3
Central Fragment of 'Le Déjeuner
sur l'Herbe'

OIL ON CANVAS, 248 x 217 CM. 1865–7. PRIVATE
COLLECTION

interested in painting landscapes and scenes of modern outdoor life, wanting their paintings to convey the way in which modern man saw the world around him. Very influential on their ideas about modernity was Charles Baudelaire's essay about the graphic artist Constantin Guys, *The Painter of Modern Life* (published in 1863), which urged the artist to study closely the fashionable scenes around him, and yet to remain detached from them; such observation, for Baudelaire, best conveyed the 'heroism of modern life'.

One way to preserve the immediacy of what they saw was to paint studies directly from the subject, in the open air; this in itself was nothing new, as French landscapists since the mid eighteenth century had regularly made notations of natural effects in oils before the motif, but Monet and his friends became increasingly concerned to retain a sense of directness in their finished works. During the 1860s, for the most part, they maintained the traditional distinction between outdoor studies and larger, more

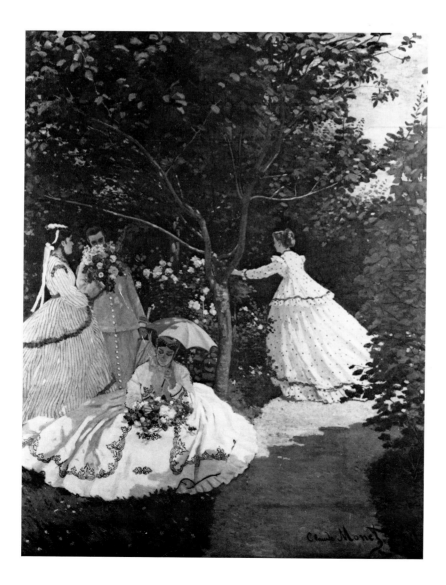

Fig. 4
Women in the Garden

OIL ON CANVAS, 255 x 205 CM. 1866–7. PARIS, MUSÉE
DU LOUVRE, JEU DE PAUME

highly finished paintings executed in the studio for the Salon, but, after the failure of his *Déjeuner sur l'Herbe*, Monet made one grand attempt to paint a monumental Salon painting out of doors — *Women in the Garden* (Fig. 4), which was rejected by the Salon jury in 1867; to paint the top of this eight-foot-high canvas on the spot, Monet had to lower its base into a specially dug ditch. After this, though, he realized that working on this scale was incompatible with the direct methods needed in the open air, and thereafter painted his few large exhibition pictures in the studio.

In the same years, Monet painted many smaller scenes of outdoor subjects, which were probably largely executed on the spot (Plates 4, 5 and 10), though the precise finish of some of them suggests that they were completed at his leisure in the studio. In scenes of Paris and the Normandy coast, he recorded strolling fashionable figures and fishermen and their boats by the sea; the high viewpoints and loosely structured compositions of some of them (Plate 4, for instance) suggest that Monet was aware of other contemporary images of the modern scene, in prints and illustrated magazines, and the groupings in his figure-paintings of the period (such as Fig. 4) are reminiscent of fashion-plates. These informal compositions helped Monet to achieve a Baudelairean spirit of detachment from his subjects. *Terrace at Sainte-Adresse* (Plate 5), with its grid-like composition set up by the flag-poles, is, as Monet himself admitted, an early example of the impact that Japanese colour-prints had on him. The new art of photography has been cited as an influence on pictures like these, but contemporary urban photographs are very close in conception to the prints and graphic illustrations of the period, and Monet's paintings, with their crisp handling and clear colour, bear little relationship to the specifically photographic elements in these small monochrome photographs.

During the 1860s, Monet began to use colour differently, moving from the comparatively subdued scheme of *The Pointe de la Hève at Low Tide* (Plate 1) to brighter and more contrasting hues. The posthumous influence of Eugène Delacroix (1799–1863) was of great importance for the development of the Impressionists' colour; his paintings, and his recorded comments published after his death, taught them how juxtaposed areas of contrasting colour could be used to brighten and enliven a whole scene. Monet first put these ideas into practice in sunlight scenes; *Terrace at Sainte-Adresse* (Plate 5) is an early example, with strong contrasts of reds and greens in the flowerbeds, and soft blues in the open shadows set against the light creamy tones of the highlights.

However, Monet's boldest works of the 1860s were his less finished paintings — notably some stormy seascapes, such as *Stormy Sea at Etretat* (Fig. 5), in which he used the brush with great freedom to suggest the textures of the scene, and the studies which he made at La Grenouillère in the summer of 1869 (Plate 9 and Fig. 20). These studies were meant as preparations for a large painting (now lost) of the scene designed for the Salon of 1870, but, in retrospect, the studies have acquired far greater

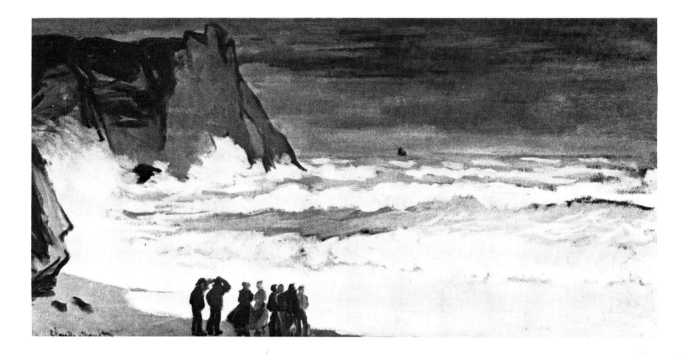

Fig. 5
Stormy Sea at Etretat

OIL ON CANVAS, 66 x 131 CM. 1868–9. PARIS, MUSÉE
DU LOUVRE, JEU DE PAUME

status than Monet meant for them when they were painted, since in their summary treatment of figures and reflections in water they anticipate many of the features of his work during the next decade. Their degree of finish is quite unlike that of the large figure-painting that Monet submitted unsuccessfully to the Salon in 1870, *Luncheon* (Plate 7); this too is broadly handled, with vigorous separate strokes of the brush, and has a markedly asymmetrical, cut-off composition, but its details are much more clearly defined and precisely described than those in the La Grenouillère studies; the whole scene has clear focuses of attention instead of revolving around a wide unfocused area of reflections, treated as simple slabs of paint.

The later 1860s saw Monet working at various sites in and around Paris, in the Seine valley, and on the Normandy coast. He relished the artistic debates between writers and painters at the Café Guerbois, which he visited when in Paris, but found it easier to work in solitude, as he wrote to Bazille from the coast in 1868: 'In Paris one is too preoccupied with what one sees and hears, however strong-minded one may be, and what I shall do here will at least have the virtue of being unlike anyone else's work, because it will simply be the expression of my own personal experiences.' He was honeymooning at Trouville with Camille and their son Jean when the Franco-Prussian War broke out in July 1870. To escape conscription, he fled to London, and thence to Holland. The paintings of Turner and Constable have been said to have influenced Monet's work at this time but his work shows little sign of it; in 1870–1, he could not have seen Constable's freest oil-studies, and the richness of Turner's colour

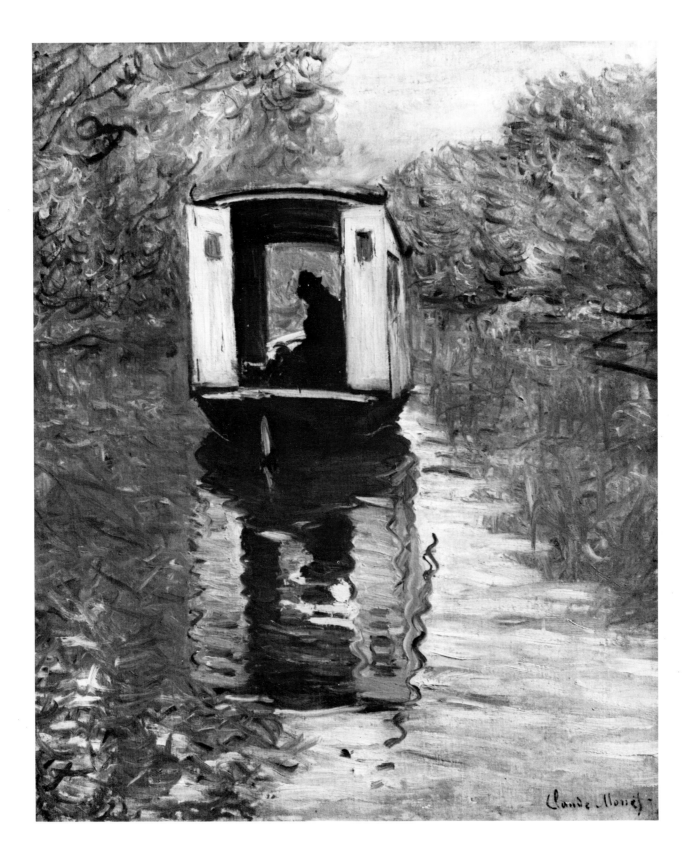

12

is not echoed in his work of this period. The mistiness and flat simple paint-layers in the background of *The Thames and the Houses of Parliament* (Plate 11) are, if anything, nearer to Whistler's contemporary work (see Fig. 22), though there is no firm evidence that the two men met at this point. On the Thames and the rivers of Holland (Plate 13), Monet was able to pursue his fascination with reflections in water, seen in different conditions of wind and lighting.

On his return to France at the end of 1871, Monet settled at Argenteuil, a village on the Seine just outside Paris, famous for its boating and regattas; here he made his base until the beginning of 1878. Many of Monet's friends came to paint with him there — Sisley, Renoir and Manet among them — and it is the long sequence of paintings executed in and around Argenteuil which have, more than any others, become the quintessence of Impressionism. It was there, too, that Monet acquired his studio boat, in which he made painting-trips up and down the river (see Fig. 6). His paintings of the area show, from all points of view and in all weathers, the stretch of the Seine which passes Argenteuil, and many parts of the surrounding countryside; sometimes the scene is rural, often the river is alive with sailing boats, and sometimes the view is backed by the factory chimneys which were then encroaching on the place (Plates 14, 16, 17, 18 and 20). Monet continued, on occasion, to include in his paintings the specifically modern, industrialized aspects of Paris and its surroundings until the later 1870s, and this interest culminated in 1877 in a series of views of the Gare Saint-Lazare and its surroundings (for example Plate 22 and Fig. 29).

During the 1870s Monet did not submit any paintings to the official Salon. In 1872-3, he had a ready outlet for his work in the dealer Paul Durand-Ruel, whom he had met in London, and from 1874 onwards he and his friends organized a sequence of group exhibitions, which aroused considerable opposition and controversy in the press, without winning for them the recognition they sought. Durand-Ruel's financial difficulties later in the decade, combined with the commercial failure of their exhibitions, meant that Monet (never the best financial organizer) was often short of money, and was forced to plead for help from a few faithful friends and collectors.

Monet used the group exhibitions to mirror the variety of his work. He generally included one or more large paintings (for instance, *Luncheon*, Plate 7, rejected at the 1870 Salon, was included in the first show in 1874 and *La Japonaise*, Fig. 28, in that of 1876), otherwise showing a selection of his smaller pictures — mainly outdoor scenes. These smaller paintings, rarely more than thirty inches across, formed the bulk of his work in the 1870s, and most of them must have been largely painted out of doors. Paintings of this sort were not considered important enough for the Salon, and, by including them in their own shows, the Impressionists were in

Fig. 6
The Studio Boat

OIL ON CANVAS, 72 x 60 CM. C.1876. MERION, PENNSYLVANIA, THE BARNES FOUNDATION

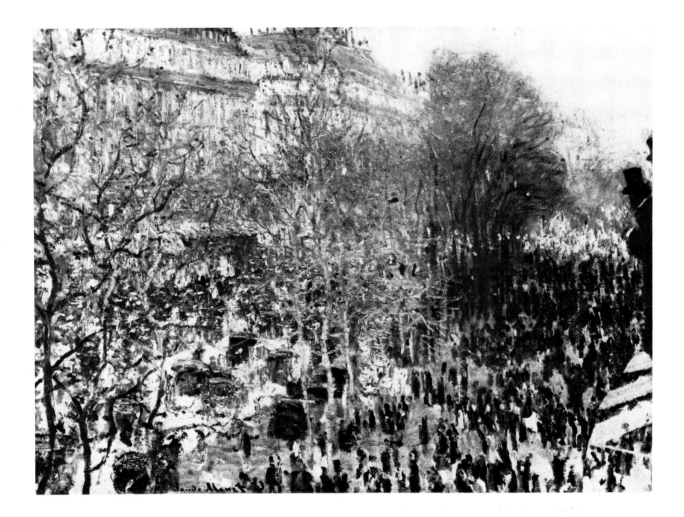

effect creating a new form for the exhibition painting, tacitly declaring that it could be a more spontaneous and less elaborate expression of the painter's response to his subjects, and that an outdoor study could be suitable for exhibition. However, even these smaller paintings vary considerably in finish and in the way they convey their subjects: in the first show, for instance, Monet included a comparatively elaborate view of the Boulevard des Capucines (Fig. 7) alongside a very lightly worked painting, the notorious *Impression, Sunrise* (Plate 15), whose title led a critic, Louis Leroy, to christen the painters 'Impressionists'.

Monet later said that he had called this painting an 'impression' because it could not pass as a view of the place; this use of the term 'impression' had been standard in art criticism over the past decade, to describe quick notations of atmospheric effects. In some later exhibitions, too, Monet juxtaposed such very summary works (often subtitled 'impression' or 'sketch') with other more highly finished versions of similar subjects (see Plates 22, 24). In a sense, these juxtapositions reflect a basic paradox in his ideas about his own painting — when working out of doors, he was tremendously proud if he could capture an effect in a quick and spontaneous sketch, but, as he grew older, he came increasingly to value the

qualities which he could give to a painting by working at it over a period of time.

During the 1870s, Monet's colour became brighter, and he depended less on contrasts of dark and light tones to suggest light and shade. In open sunlit scenes (Plates 17, 18, 20, 21), he began to use blues in the shadows in grass and trees, and to express the fall of sunlight by treating the greenery in gradations of colour, from blue through various nuances of green to light yellow-greens and yellows in the highlights. It was by this subdivision and modulation of colours, used to express forms and space, that the Impressionists found a way of avoiding traditional chiaroscuro modelling (by gradations from dark to light tones). However, Monet did not at once use these new methods in all his paintings; in a sunlit autumn effect in 1873 (Plate 16), he could reduce the whole surface to a network of nuances and contrasts of clear light colour, but his more overcast scenes remain much more tonal in treatment (Plate 22), though gradually he introduced soft colour-variations into all areas even in these more subdued effects.

At the same time, Monet was changing the way he used brushstrokes to convey the subjects in his paintings. In *The Riverside Walk at Argenteuil* of 1872 (Plate 14), he varied his touch according to the different objects in the scene, but was willing to leave considerable areas quite smooth, with few variations of texture; by contrast, later in the decade he began to variegate the whole surfaces of his paintings with small touches of paint; though still based closely on the actual features of the subject, these give his canvases an overall mobile surface (Plate 20, for instance). Comparison of two figure-paintings, one of about 1868-9, the other of 1875, reveal this change (Plates 8 and 21): *The Red Cape* still echoes Manet's handling, with broad simple zones of paint set off by decisive individual dabs and dashes with the brush; in *Woman with a Parasol*, the natural forms of grass, figures, and sky become part of a much more continuous broken rhythm, which is augmented by the relationships of clear, varied colours. It was the handling and colour of paintings such as this which seemed so revolutionary and unintelligible to the public of the 1870s.

The course of Monet's life changed markedly in 1878. He left the Paris area and moved to Vétheuil, a secluded village further down the Seine, partly because life was cheaper there, but also, one suspects, because the continued commercial failure of the group exhibitions had left him disillusioned about the prospects offered by any collective activities. With him he took his wife (now sick) and children, together with the wife and children of his former patron, the now ruined financier Ernest Hoschedé. Monet's wife died in 1879, and Hoschedé became increasingly estranged from his family; this led Monet's ménage with Alice Hoschedé to become a permanent arrangement, finally formalized by their marriage in 1892, after Hoschedé's death. Monet's break with the Impressionist group was highlighted in 1880 when, instead of showing at that year's group

exhibition, he sent to the official Salon two large paintings executed in the studio from smaller outdoor studies; the more conventional one, a summer scene (Plate 26), was accepted but badly hung, while the other, a dramatic canvas of ice-floes (Plate 25), was rejected. Never again did he send a painting to the Salon, but thereafter generally exhibited in one-man shows organized by dealers. In 1881, Monet attained a comparative financial security, when Durand-Ruel started again to buy his work regularly, but true commercial success only arrived at the end of the 1880s when collectors in the United States took him up in earnest.

While at Vétheuil Monet restricted his subjects to the village and the hamlet of Lavacourt which faces it across the Seine, and the banks of the river. Many subjects he painted on more than one occasion (Plates 23 and 24), trying to capture the aspects of the area in all seasons and weathers — spring, summer, the sun coming through the morning fog (Plate 24), and the effects of ice in the remarkable winter of 1879–80 (Plate 25). His letters show that these desolate winter landscapes helped him to recapture his faith in painting after the death of his wife; his portrayals of this natural drama allowed him to overcome his grief. His views of the Vétheuil area are generally simple and horizontal in emphasis, often seen frontally across the river; they depend for their variety on the endless changes of foliage, weather, and lighting. At this period, too, he painted his most singificant group of still-lifes — bouquets of flowers and arrangements of fruit (Plate 27 and Fig. 33), all disposed across the canvas with a freedom and informality that was to influence Van Gogh deeply. In 1883, Monet moved his base to Giverny, a little village rather further down the Seine valley, where he was to live for the rest of his life. Here he chose motifs similar to those at Vétheuil, often deliberately anti-picturesque in effect, of simple meadows, orchards, bands of hills, and banks of trees, enlivening these deceptively simple subjects by delicate variations of colour and brushwork (Plate 31).

However, the bulk of Monet's work during the 1880s was done on a long series of journeys, initially to the coastal resorts of Normandy such as Fécamp, Etretat and the area round Dieppe (Plates 28 and 29), and later to the Mediterranean coast (Plates 30, 33 and 34), to the island of Belle-Isle off Brittany (Plate 32), and to the valley of the Creuse Massif Central (Plate 36). In his paintings from these journeys, h centrated on the most dramatic aspects of each location — the unex vistas from the tops of the Dieppe cliffs, the vast rock-arches at I (see Fig. 8), the lavish colour and vegetation of the Riviera, the beating on the granite rocks of Belle-Isle. Taking up again the chal set him by the ice-floes at Vétheuil in 1879–80, Monet went on expl themes of elemental oppositions and extremes of weather and ligh He consciously wanted to extend the range of his own painting, to pr that no natural effect was too transitory or too powerful to be captured a determined outdoor painter; the descriptions which have come down

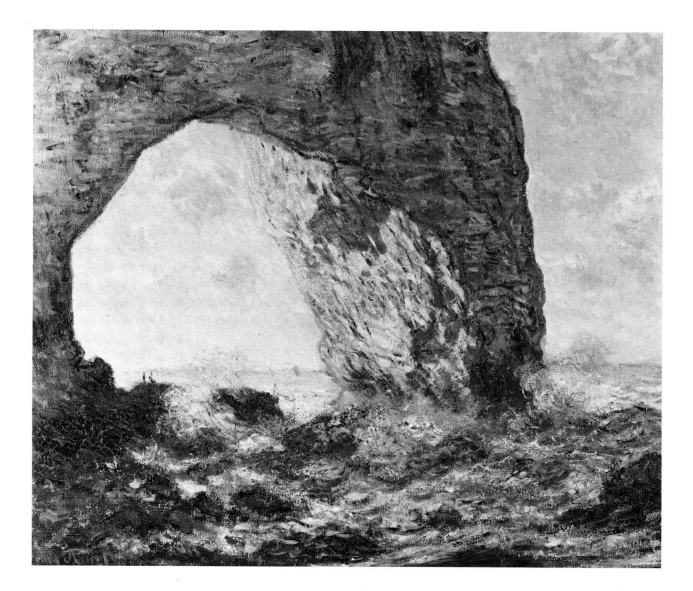

Fig. 8
The Manneporte, Etretat

OIL ON CANVAS, 65 x 81 CM. 1883. NEW YORK, THE
METROPOLITAN MUSEUM OF ART

us of his working methods at this period show that at times he deliberately courted the most hostile weather conditions. On one occasion while painting the Manneporte at Etretat (Fig. 8), he was swamped by a vast wave, when he had mistimed a session of painting on the beach after misreading the tide tables; in the gales on Belle-Isle, his easel had to be tied to the rocks (see Fig. 36); in snow and ices his beard grew icicles, and he had himself fastened to the ice, with a hot-water bottle to keep his hands warm enough for him to paint.

Monet intended his groups of paintings of different sites each to have some dominant mood, and played off one group against another. On occasions, he went to great lengths to preserve such a mood. In 1889, he meant his paintings of the Creuse (Plate 36) to be of stark winter effects, in contrast to the lightness and delicacy of the Antibes views of the previous year (Plates 33 and 34). However, his work in the Creuse was delayed by rain, and spring buds started to grow on a great oak tree which he was

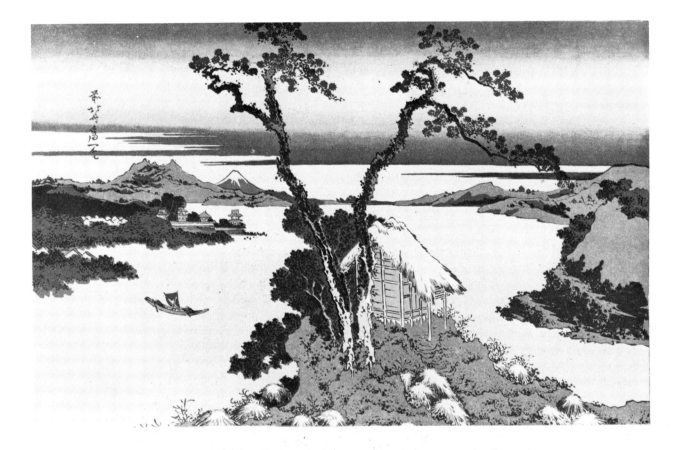

painting; rather than lose his winter effect, he employed workmen to strip off buds before he would finish his picture, so strong was his preconception of the type of effect he wanted to paint.

To convey the extreme effects he had chosen to tackle, Monet had to find pictorial equivalents for the forms he saw before him. The act of composition, for an outdoor landscape painter, involves choosing a viewpoint and deciding how the edges of the canvas are going to cut the scene before him. In his coastal scenes, Monet favoured views from the clifftops, with a heavy cliff mass on one side set against the wide expanses of the sea, and, sometimes, the sinuous lines of silhouetted trees (Plates 28, 29, 32 and 33); this led him to dispose his forms in ways very like Japanese landscape prints, of which he was an avid collector (see Fig. 9). These prints must have helped him to find the compositional patterns which would best convey the characteristics of such scenes. For Monet, the art of Japan was a form of naturalism, which helped revitalize his way of seeing his own surroundings; he did not seek the philosophical meaning that Van Gogh found in it, nor did he use it as a sanction for stylized decorative arabesques, as did Gauguin and the Art Nouveau artists.

At the same time, dramatic sunsets, such as that in *Varengeville Church* (Plate 29), forced him to find a way of translating into paint the most lavish of natural colour-schemes, and he responded by keying up his colour to greater intensity, and by emphasizing the contrasts between

complementary colours — oranges and reds set against blues and greens. The problem of suggesting in a painting the full luminosity of sunlight was highlighted by his experiences on the Mediterranean coast in 1884 and 1888. His letters from the South harp on the difficulty of adjusting his palette to the conditions, and on the pervading blue and rose colours of the atmosphere; to convey this, he adopted a luminous colour-range with accents of hot colour, and emphasized this blue-rose contrast, giving his southern paintings carefully integrated colour-schemes (Plates 30, 33 and 34). Monet, by his own experiences of painting, had discovered the truth of the maxim uttered many years later by his friend Paul Cézanne (1839–1906): 'I was very pleased with myself when I discovered that sunlight cannot be *reproduced*, but that it must be *represented* by something else — by colour.' *Varengeville Church*, predating Monet's southern trips, shows that these experiments did not begin with his Mediterranean work. His later northern paintings show an increasing emphasis on carefully coordinated colour harmonies as a means of suggesting atmospheric effects, which reaches its height in his series of Haystacks and of Rouen Cathedral in the early 1890s (Plates 37–9, 41).

Monet also adapted his brushwork to the demands of his new range of subjects — particularly the palm-trees of Bordighera (Plate 30), and the stormy waves of the Channel and Atlantic (Fig. 36). He used the brush in an almost calligraphic way, suggesting the movements of the forms in front of him with long flowing curls and ribbons of paint; this handling creates an emphatic pattern on the canvas, since the brush-strokes remain clearly visible as such. Paint-surfaces of this sort, with Monet's more unified colour-schemes of the period, help to make his pictures far more decorative in their overall effect than his characteristic paintings of the High Impressionist phase of the 1870s; but at the same time they still convey a strong sense of the actual forms, colours, and space of the scene which Monet had before him.

This growing emphasis on two-dimensional qualities in Monet's paintings of the 1880s corresponds to a gradual change in his working methods. Outdoor painting remained essential to him as the starting point for his pictures, and he still valued highly the ability to suggest quickly and directly the effect of a scene; but he began to feel the need to look over every painting back home in the quiet of his studio, and to retouch it at his leisure. His dealers found that it took longer to prise his latest paintings from him, and from his letters it is clear that many of the paintings from his travels reached home in quite a rough state, needing considerable reworking to make them saleable, particularly since Durand-Ruel was urging Monet not to part with inadequately finished paintings. This retouching seems to have taken various forms — re-emphasizing features not clearly enough defined, heightening the colours of a scene, sharpening the contrasts between different elements within the painting, and finally adding touches that would knit together the colour relationships and

inflexions of brushwork into a single harmonious pattern; he also began to sign his pictures in colours that harmonized with their colour-schemes. His studio reworking was not in conflict with the initial, outdoor stages of the painting, which must normally have established the main elements of the picture; but it accentuated, on the paint-surface, the relationships which the motif had suggested. In *Varengeville Church* (Plate 29), the red strokes on the hillside by the left margin, which lead the eye down from the sunset and across to the foreground bushes, are examples of the sort of accents which Monet is likely to have added in the studio; in paintings of the 1890s, such as the series of Haystacks and Rouen Cathedral, the rich colour-schemes seem to have been considerably elaborated away from the motif.

During his period of restiveness in the 1880s, Monet flirted for the last time, in the later part of the decade, with the idea of becoming a figure-painter. Following the advice of friends, among them Renoir (who was at the time turning back to the nude and to traditional methods), he began to paint figures in the fields around Giverny (Plate 35), and compositions of girls in boats on local streams (Fig. 37), using as models his and Alice Hoschedé's children, since she threatened to walk out on him if he employed a professional model. However, he seems to have found it difficult to apply to the figure his ways of treating landscape, and after 1890 figures almost wholly disappear from his paintings.

In 1890, there was a sudden change in Monet's patterns of work. He stopped travelling, and focused instead on a series of paintings of a single subject — of one or two haystacks variously grouped in a field by his house at Giverny (Plates 37–9, Figs. 10 and 38). Fifteen of these he exhibited together the following spring, and they were followed by other equally unified series — Poplars in 1891–2 (Plate 40), Rouen Cathedral in 1892–4 (Plate 41), and many others; this became Monet's standard way of working for the rest of his life. His new-found financial security may well have been the catalyst which allowed him to embark on these experiments at this stage of his career; freed from the pressures of being his own salesman, he could now concentrate on a single pictorial problem for a considerable period.

In some ways, the series continue tendencies in his previous painting, but in others they take a quite new direction. Since the 1860s, Monet had, on occasion, painted more than one canvas of a single subject under different conditions (Plates 23 and 24, of 1879, are an example), and, during the 1880s, he sometimes painted the same motif six or more times (for instance, the Pyramides at Port-Coton on Belle-Isle, Plate 32), moving on to a different canvas when the light-effect in front of him changed. But he did not at that stage treat these groups of paintings as separate units: in his exhibitions he tended to emphasize the variety of motifs which

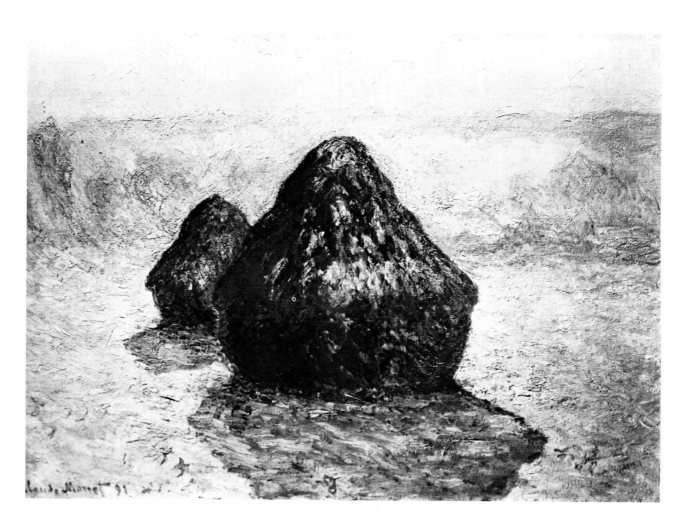

Fig. 10
Haystacks, Snow Effect

OIL ON CANVAS, 65 x 92 CM. 1891. EDINBURGH,
NATIONAL GALLERY OF SCOTLAND.

he had treated at any location, rather than including several versions of a single subject, since he continued to treat exhibitions as a shop-window for the full range of his work. He had in a sense presaged the idea of exhibiting such groups together at the Impressionist exhibition of 1877, by including eight views of the Gare Saint-Lazare and its surroundings (including Plate 22 and Fig. 29); but these were very varied in viewpoint and composition, and were only one of the many aspects of Monet's art seen at this exhibition. In the Haystacks of 1890–1 and in his later series, Monet was creating a unity which could only be properly appreciated when they were first exhibited and all could be seen together, since, as Monet told a visitor to the Haystacks show, the individual paintings 'only acquire their value by the comparison and the succession of the entire series'. The exhibition itself, rather than just the paintings which made it up, had now become the work of art. Only at the Jeu de Paume in Paris, which houses five of the Rouen Cathedral series, can we begin to appreciate this effect today.

In their subjects, too, the early series, notably the Haystacks and the Poplars, are quite unlike Monet's previous work. They wholly lack topographical interest, telling us nothing about the area in which Monet was

painting; even the Rouen Cathedral paintings, once one has seen one of them, have nothing more to tell us about the architecture of the faccade. Instead, the emphasis is on atmospheric variations, on the way in which every successive light-effect modifies and transforms the appearance of the forms. Monet wrote in 1890 that in the Haystack paintings he was trying to capture ' "instantaneity", above all the enveloping atmosphere, the same light diffused over everything', and commented the next year: 'For me, a landscape does not exist in its own right, since its appearance changes at every moment; but the surrounding atmosphere brings it to life — the air and the light, which vary continually. For me, it is only the surrounding atmosphere which gives subjects their true value.'

This concentration on almost tangible effects of atmosphere takes up a theme which had fascinated him for twenty years — since he had painted the Thames in 1870–1 (Plate 11). His most celebrated single picture, *Impression, Sunrisie* (Plate 15), had treated this theme, as had *Vétheuil in the Fog* (Plate 24), a painting he had exhibited on several occasions in the 1880s as a symbol of the ephemeral effects he was trying to record. Mist effects are predominant in most of his series of the 1890s, and it was the winter mists and fogs of London which led him back to paint there in 1899–1901 (Plate 45), as he told René Gimpel: 'I like London only in the winter; without the fog, London would not be a beautiful city. It is the fog which gives it its marvellous breadth. Its regular, massive blocks become grandiose in this mysterious cloak.'

Monet's earlier paintings of mists were just isolated canvases, quickly painted. However, in the series of the 1890s, he found a way of making something more permanent out of these most transitory effects. He told a friend at the time that he had become dissatisfied with painting 'anything that pleased him, no matter how transitory'; instead, he had to 'keep at a thing for a certain space of time', and was seeking 'more serious qualities' in his pictures. He pursued this by following further the direction which his working methods had taken in the 1880s — reworking his paintings over a longer period in the studio, and emphasizing their harmonious colour-schemes. He still began virtually all his canvases in front of the subject, but was painting effects so ephemeral that he had little chance to work them fully on the spot; back in his studio, he elaborated and enriched them, often reworking one canvas by comparison with others in the same series, until some of his paintings, such as those of Rouen Cathedral (Plate 41), are far from any immediate perceptual experience of the building, suggesting instead by the subtlety of their colour harmonies the transforming qualities of sun in mist. It is not surprising to find that Monet's admiration for Turner was at its height at this period. These paintings are far from the freshly coloured notations which had given Impressionism its reputation in the 1870s; they create a suggestive, evocative atmosphere which has much in common with the symbolism of Monet's friend, the poet Mallarmé.

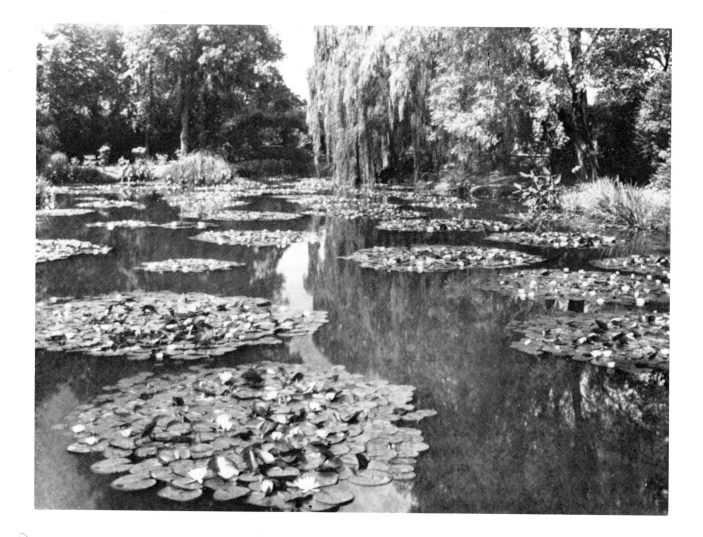

In the early 1890s, Monet began to build himself a water-garden at his home in Giverny, making a pond by diverting a stream, and building a bridge over it; Fig. 11 shows the pond in its final state. Initially, he had no thought of painting the garden, but he soon came to see its pictorial possibilities. In the first series (Plates 43 and 44), flowers, overhanging trees and bridge surround the water and its lily-pads. After 1900, Monet enlarged the pond, and embarked on a series, only exhibited in 1909, in which the banks of the pond are first pushed to the top of the canvas, and then disappear althogether; the whole picture is given over to the surface of the water with lily-pads set off against reflections of trees, clouds, and sky (for instance, Fig. 43).

Monet had since the late 1890s cherished the idea of transforming his paintings of the lily-pond into a single decorative scheme, which would run continuously round a room. Only in 1914 did his friend the politician Clemenceau persuade him that it was not too late to start work on such a project, and Monet began in 1916, in a vast studio built for the purpose, to paint a succession of huge canvases, two metres high, of the water surface, working from memory and from smaller studies made by the pond.

Fig. 11
Photograph of Monet's Lily-Pond,
c.1930

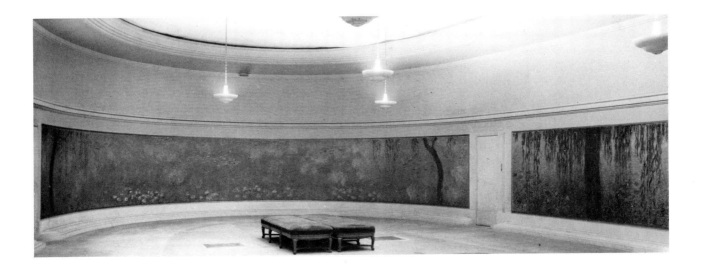

Near the end of his life, he selected some of these for installation in two oval rooms in the Orangerie in Paris, where they remain, presented as Monet had planned (see Fig. 12). The large paintings not selected for the Orangerie emerged from Monet's studio during the 1950s, and can be appreciated in photographs more easily than the ensembles in the Orangerie; but these too are handled on a scale and with a freedom which can only be sensed from the paintings themselves (Plates 46 and 47; detail, Plate 48).

In these water-surfaces, Monet had chosen a subject still more ephemeral, if this is possible, than the mists of the series of 1890s; late in his life, he told an interviewer what he was seeking: 'The water-flowers themselves are far from being the whole scene; really, they are just the accompaniment. The essence of the motif is the mirror of water, whose appearance alters at every moment, thanks to the patches of sky which are reflected in it, and which give it its light and movement. The passing cloud, the freshening breeze, the light growing dim and then bright again, so many factors, undetectable to the uninitiated eye, transform the colouring and distort the plane of the water. One needs to have five or six canvases that one is working on at the same time, and to pass from one to the next, and hastily back to the first as soon as the original, interrupted effect has returned.'

The water-lily decorations dispense almost completely with the conventional ingredients of painting. They have no clear compositional focus; as on the pond itself, the lily-pads float freely across the whole breadth of the canvases, which seem as if they could be continued indefinitely beyond their side margins. This sense of continuity across their surfaces is increased by their very homogeneous colour-schemes — generally light in tonality, and mostly within a narrow range of colour, in variations of greens and blues, with yellows and mauves. Their brush-

work explores further the free calligraphy which Monet had used in the 1880s to describe lavish foliage and stormy seas. When one moves close to these canvases, the individual strokes of paint sweep boldly across their surface, without being firmly tied to the forms which they suggest, and the colour-nuances give a rainbow-like pigmentation to the skin of the painting (see detail, Plate 48); at a distance, the colour and brushwork coalesce into broad harmonies and rhythms, drawing the whole activity of the paintings up on the picture-plane, but, as one contemplates it, this surface becomes the broad surface of the pond which is the paintings' subject.

Monet's devotion to nature and the lyrical handling of the water-lily canvases seemed outmoded to younger artists in the 1920s and 1930s; but the implications of these open-structured paint-surfaces have since 1945 been fully explored by Abstract painters in the United States and Europe, whose experiments have led artists and critics to a reassessment of Monet's whole *oeuvre*. However, Monet was a man of his own generation. Like Cézanne (the prophet of much of the formalist abstraction of the earlier years of the twentieth century), Monet throughout his career sought ways of conveying his sensations of nature. But, within this broad framework, he extended the vocabulary of naturalism in painting, by freeing colour, brushwork, and composition from many outworn conventions, and using them to create a new sort of pictorial coherence. In Monet's paintings, the harmonies and rhythms of colour and brushwork become the equivalent of the unifying effects of light and atmosphere in nature.

Outline Biography

1840 Born in Paris, 14 November.

*c.***1845** Family moves to Le Havre.

*c.***1857** Meets Boudin, who introduces him to landscape painting.

1859–60 Stay in Paris; meets Pissarro.

1861–2 Military service in Algeria.

1862 Meets Jongkind.

1862–4 In studio of Gleyre, where meets Renoir, Bazille, Sisley.

1865 First exhibits at official Paris Salon; shows again in 1866 and 1868; rejected in 1867, 1869 and 1870.

*c.***1866** Meets Manet, later a close friend.

1870 Marries Camille Doncieux.

1870–1 Visits London, then Holland, as refugee from Franco-Prussian War and Commune.

1871–8 Based in Argenteuil, where Manet, Renoir and Sisley visit him on occasions to paint.

1874 Contributes to the first Impressionist exhibition; also shows in the exhibitions of 1876, 1877 (including Gare Saint-Lazare paintings), 1879 and 1882.

1878–81 Lives at Vétheuil, with his family, and with Alice Hoschedé and her children.

1879 Death of Monet's wife Camille.

1880 Exhibits for the last time at the official Salon.

1880–9 Decade of travels.

1880–6 Painting trips to Normandy coast, each year.

1881–3 Lives at Poissy.

1883 Moves to Giverny, where he lives for the rest of his life.

1884 First painting trip to Mediterranean, to Bordighera and Menton; visits Antibes in 1888.

1886 Paints in Holland and on Belle-Isle.

1889 Paints in valley of Creuse; Retrospective exhibition at Petit's Gallery in Paris wins great acclaim.

1891 Exhibition of his first true series, the Haystacks.

1892 Marries Alice Hoschedé.

*c.***1893** Begins construction of water garden near his house at Giverny.

1895 Visits Norway; exhibition of Rouen Cathedral series, begun in Rouen in 1892 and 1893.

1900 First Lily-Pond series exhibited.

1904 London series exhibited, begun during visits to London in 1899, 1900 and 1901.

1909 Second Lily-Pond series exhibited.

1911 Death of Monet's second wife, Alice.

1916 Begins to paint large Water-Lily decorations.

1926 Dies at Giverny, 6 December.

Fig. 13
Photograph of Monet in his Garden
in front of his House at Giverny,
c. 1920

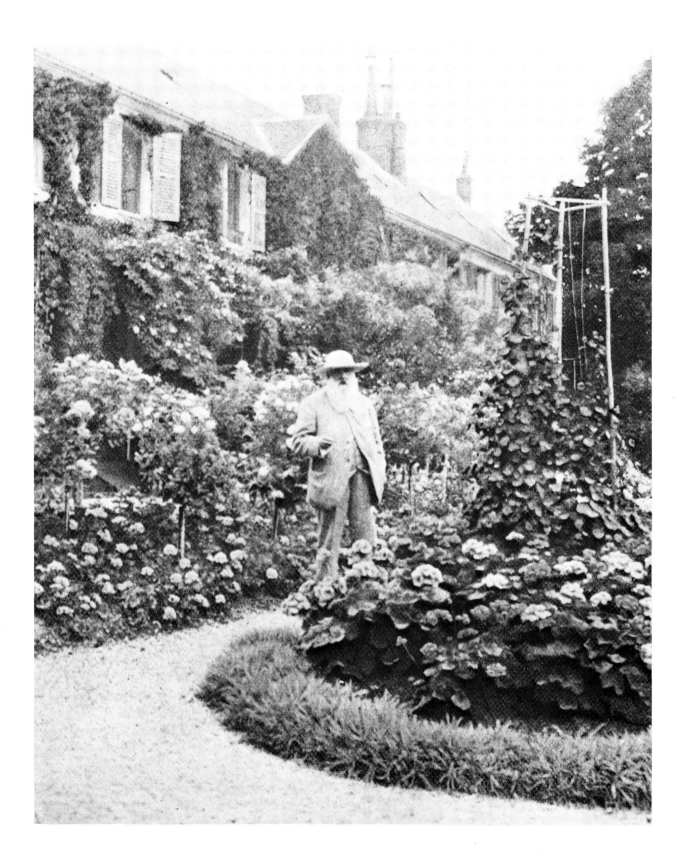

Select Bibliography

COMPLETE CATALOGUES OF MONET'S
PAINTINGS

D. Wildenstein, *Monet, vie et oeuvre*, I (1840–1881), II
(1882–1886), III (1887–1898), Lausanne and Paris, 1974
and 1979 (with full biography)
D. Rouart and J.-D. Rey, *Monet Nymphéas*, Paris, 1972
(Water-Lily paintings only)

MONOGRAPHS

G. Geffroy, *Claude Monet, sa vie, son temps, son oeuvre*, Paris,
1922; new edition 1980
W. C. Seitz, *Monet*, London and New York, 1960
G. H. Hamilton, *Claude Monet's Paintings of Rouen
Cathedral*, Oxford, 1960
J. Isaacson, *Monet, Le Déjeuner sur l'Herbe*, London, 1972
C. Joyes, *Monet at Giverny*, London, 1975
S. V. Levine, *Monet and his Critics*, New York, 1978
J. Isaacson, *Claude Monet, Observation and Reflection*,
Oxford, 1978
J. House, *Monet and the Crisis of Impressionism*, forthcoming

GENERAL BOOKS

P. Francastel, *L'Impressionnisme*, Paris, 1937, new edition
1974
L. Venturi, *Les Archives de l'Impressionnisme*, Paris, 1939
(primarily on Durand-Ruel's relations with the Impres-
sionists)
J. Rewald, *The History of Impressionism*, 4th edition,
London and New York, 1974 (standard history, with
extensive critical bibliography on Monet)

EXHIBITION CATALOGUES OF MONET'S
PAINTINGS

Claude Monet, catalogue by D. Cooper and J. Richardson,
London and Edinburgh, Arts Council of Great Britain,
1957
Claude Monet, Seasons and Moments, catalogue by W. C.
Seitz, New York, Museum of Modern Art, 1960
Monet Unveiled, catalogue by E. H. Jones, A. Murphy and
L. H. Giese, Boston, Museum of Fine Arts, 1977
Monet's Years at Giverny, catalogue by C. Moffett and D.
Wildenstein, New York, Metropolitan Museum of Art,
1978
Hommage à Claude Monet, catalogue by H. Adhémar, A.
Distel, and S. Gache, Paris, Grand Palais, 1980

GENERAL EXHIBITION CATALOGUES

The Impressionists in London, catalogue by A. Bowness and
A. Callen, London, Hayward Gallery, 1973
*Impressionism, its Masters, its Precursors and its Influence in
Britain*, catalogue by J. House, London, Royal Academy
of Arts, 1974
Centenaire de l'Impressionnisme, catalogue by H. Adhémar
and others, Paris, Grand Palais, 1974
Post-Impressionism, Cross-Currents in European Painting,
catalogue edited by J. House and MA. Stevens, London,
Royal Academy of Arts, 1979–80
The Crisis of Impressionism, catalogue by J. Isaacson and
others, University of Michigan Art Gallery, 1980

List of Illustrations

Colour Plates

Text Figures

Comparative Figures

The Pointe de la Hêve at Low Tide

OIL ON CANVAS, 90 x 150 CM. 1865. FORT WORTH, TEXAS, KIMBELL ART MUSEUM

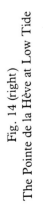

Fig. 14 (right)
The Pointe de la Hêve at Low Tide

OIL ON CANVAS, 51 x 73 CM. 1864. PRIVATE COLLECTION

The Pointe de la Hêve at Low Tide is one of the first two canvases which Monet exhibited in Paris; with *The Seine Estuary at Honfleur* (Fig. 2), it was accepted by the jury at the Salon exhibition of 1865. Both are comparatively large, a necessity for a young artist if his paintings were to be noticed in the crowded hanging conditions of the Salon, and both were painted in Monet's studio in Paris from smaller studies that he had made directly from nature during the previous summer, again a conventional procedure for making a Salon landscape. Fig. 14 was the study for *The Pointe de la Hêve at Low Tide*. In reworking the theme on a large scale, Monet omitted a cart and some horses, and made minor adjustments of the relationships between other forms, adding the breakwater at front left; however, the principal forms were retained unaltered.

The painting shows the beach at Sainte-Adresse, which adjoins Le Havre, Monet's home town, to the north east. The figures in the picture are local types, the traditional staffage of such coastal scenes, in contrast to the fashionable bourgeoisie whom Monet's mentor, Boudin, was at this time beginning to paint on the beaches of nearby Trouville. Monet in turn was soon to people his coastal scenes with fashionably dressed figures (see Plate 5). The handling and colour of *The Pointe de la Hêve at Low Tide* reflect the influence of Monet's other mentor, the Dutch landscapist Jongkind, in the varied and quite delicate touch and the subdued colour range, which relies primarily on contrasts of dark and light tones to suggest forms.

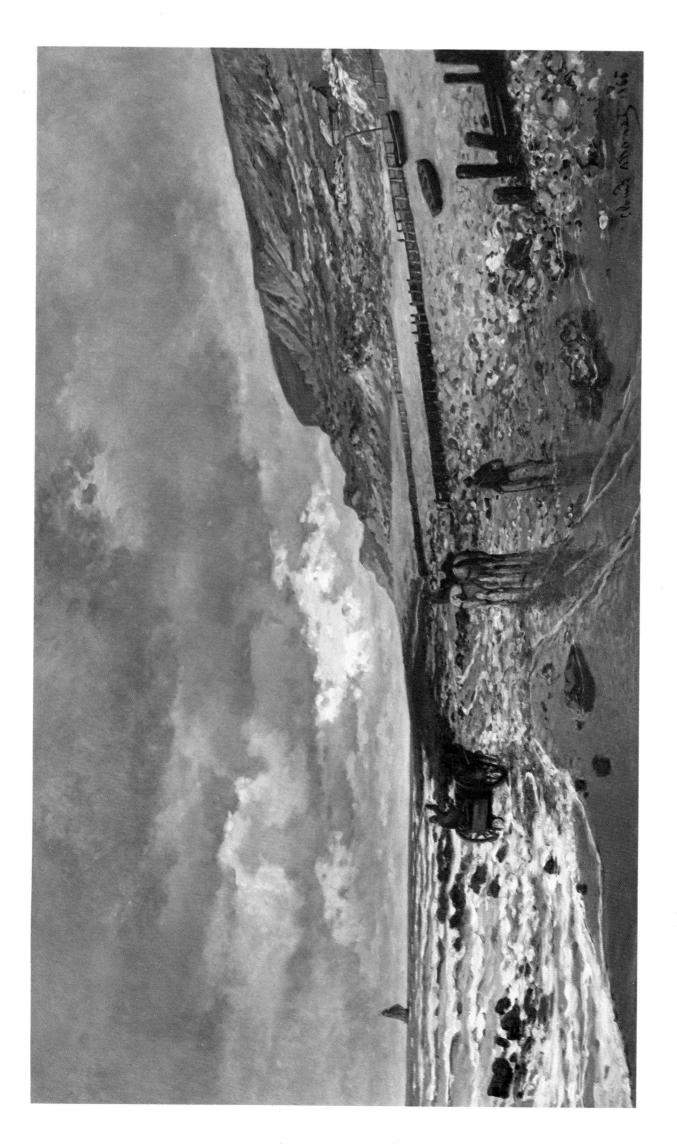

Left-hand Fragment of 'Le Déjeuner sur l'Herbe'

OIL ON CANVAS, 418 x 150 CM. 1865–6. PARIS, MUSÉE DU LOUVRE, JEU DE PAUME

After the success of his seascapes at the 1865 Salon (see Plate 1) Monet embarked on a far more audacious venture for the 1866 exhibition: a monumental reworking of the theme of Manet's *Le Déjeuner sur l'Herbe*, which had gained such notoriety at the Salon des Refusés in 1863. Starting from outdoor studies made in the Forest of Fontainebleau, and from a large painted sketch of the whole ensemble (Fig. 15), Monet tried in the studio to translate his composition onto a vast canvas, of about 4½ x 6 metres, without losing the spontaneity of handling that had characterized the studies. He hoped that the handling, and the casual informality of the figure grouping, would give his canvas a freshness and immediacy which Manet's *Déjeuner* had lacked.

Monet never completed the project: the surviving parts of the monumental canvas (Plate 2 is its left side, Fig. 3 its centre) show that he was unable to recreate the vivacity of touch on such a grand scale. However, in their unfinished state they have a directness of vision and handling, which a modern viewer can appreciate far more easily than would have been possible for the Salon audience of 1866.

Fig. 15
Le Déjeuner sur l'Herbe

OIL ON CANVAS, 130 x 181 CM. 1865 (DATED 1866). MOSCOW, PUSHKIN MUSEUM OF FINE ARTS

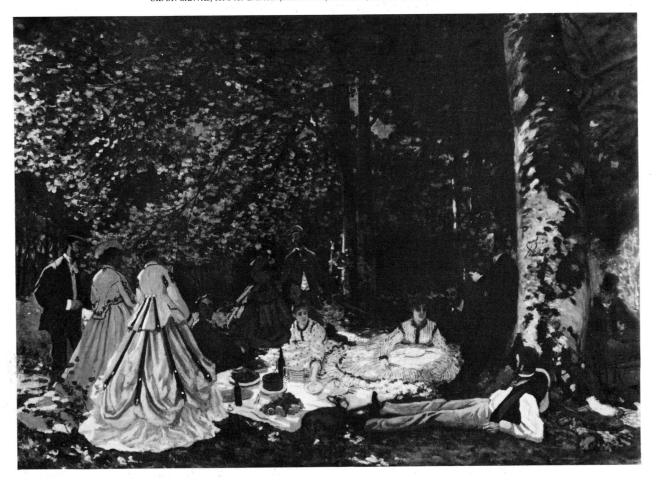

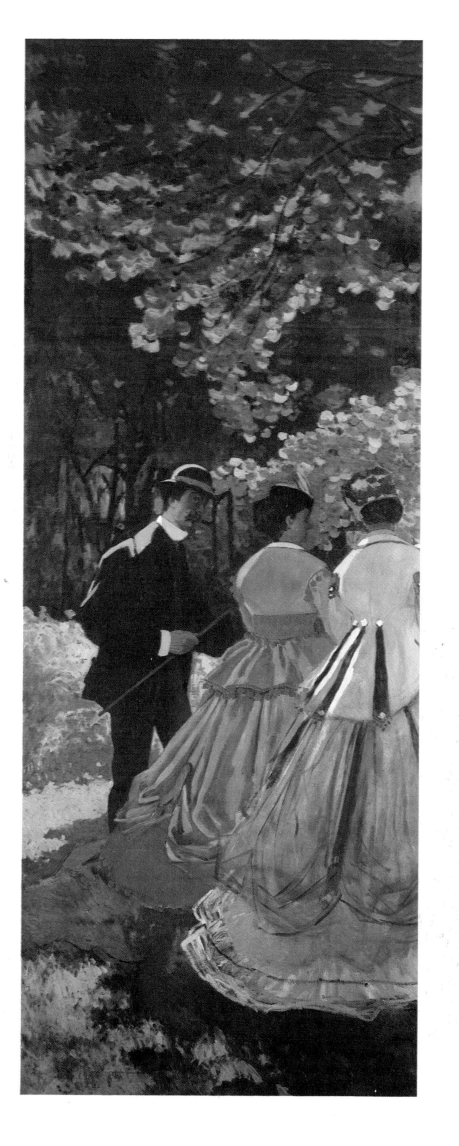

Camille, Woman in a Green Dress

OIL ON CANVAS, 231 x 151 CM. 1866. BREMEN, KUNSTHALLE

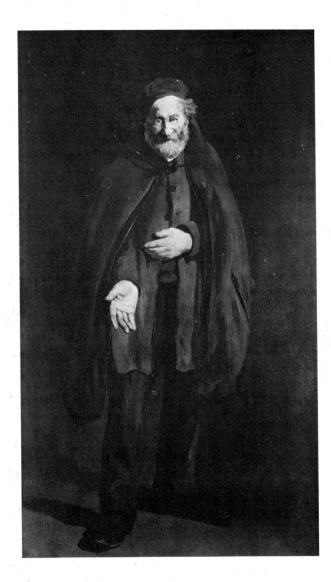

Camille, Woman in the Green Dress, a lifesize painting, was rapidly painted for the Salon of 1866 after Monet's failure to complete his *Déjeuner sur l'Herbe* (Plate 2). Executed in four days, according to the (doubtless exaggerated) stories propagated at the time, it shows clear evidence of a debt to Manet, both in the bold, incisive brushstrokes with which Monet modelled the figure and in particular her dress, and in the undefined tonal background that he used to set her off (compare Fig. 16, by Manet).

The model for the painting was Camille Doncieux, whom Monet was to marry in 1870, but the painting is not essentially a portrait. Rather it is an attempt to capture the fleeting gestures of the fashionable woman of the day, as she adjusts a ribbon. The focus is not on her physiognomy, but on her attributes, and the way in which her dress is displayed to the viewer can be compared with the arrangements characteristic of the fashion plates of the period; such prints were themselves images of the surface trappings of modern woman, and Monet, in *Camille*, adapted some of their conventions to the demands of a monumental Salon painting.

Fig. 16 (left)
Edouard Manet (1832–83):
The Philosopher with a Beret

OIL ON CANVAS, 188.5 x 109 CM. 1865. THE ART INSTITUTE OF CHICAGO
(A. A. MUNGER COLLECTION)

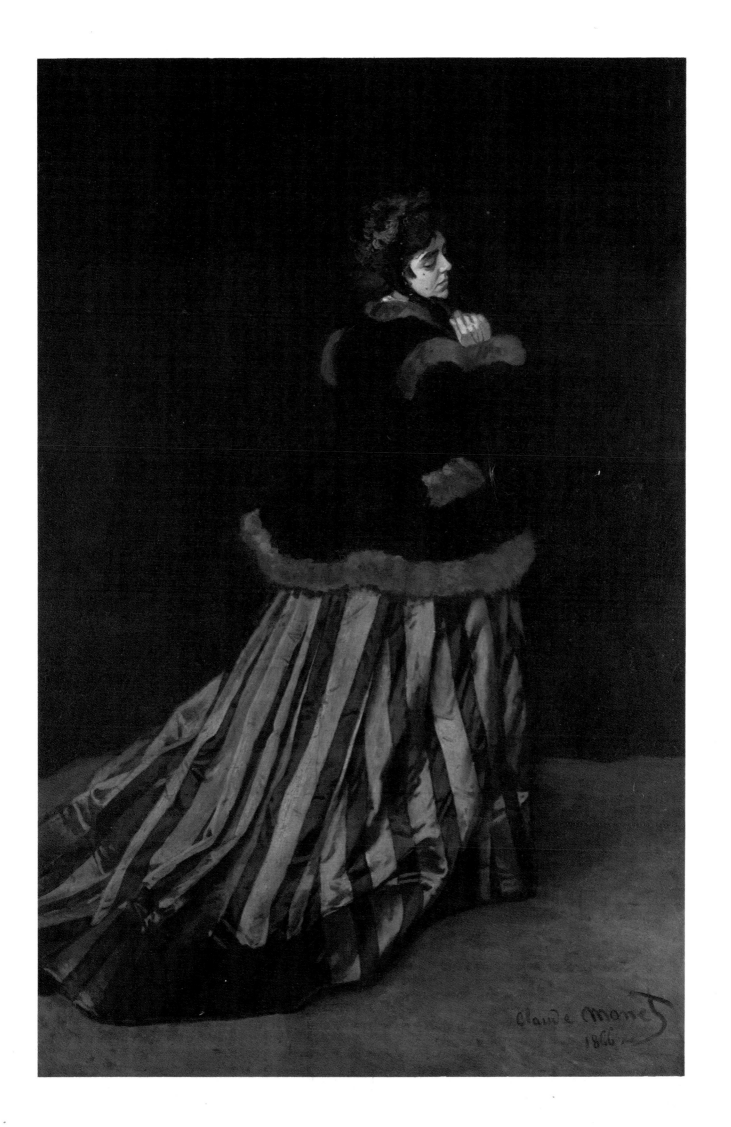

The Quai du Louvre

OIL ON CANVAS, 65 x 92 CM. 1867. THE HAGUE, GEMEENTEMUSEUM

The Quai du Louvre and *Saint-Germain-l'Auxerrois* (Fig. 17) are typical of the sort of smaller paintings that Monet executed during the 1860s for sale to collectors and through dealers, rather than as monumental showpieces for the annual Salon exhibition. They are two of a group of three canvases of 1867 showing views from the south-eastern balconies of the Louvre. *Saint-Germain-l'Auxerrois* shows the square and church directly to the east, while *The Quai du Louvre* shows, on the right, the western tip of the Ile de la Cité, with the dome of the Panthéon dominating the horizon.

By deft, economical touches of paint Monet managed to capture the characteristic gestures of the passing figures, without distracting detail or psychological content (see also Plate 12). He also carefully avoided giving his scenes any single centralized focus, in favour of the sort of dispassionate panorama often found in contemporary prints and graphic illustrations, such as the lithographic plates in *Paris dans sa splendeur* (1861). Manet adopted a similar vision in his view of the 1867 Exposition Universelle (Fig. 23).

Fig. 17 Saint-Germain-l'Auxerrois

OIL ON CANVAS, 79 x 98 CM. 1867 (DATED 1866). BERLIN, NATIONALGALERIE, STAATLICHE MUSEEN

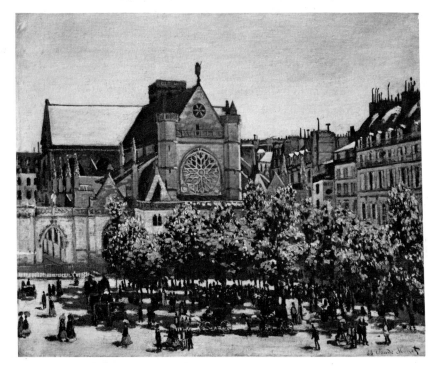

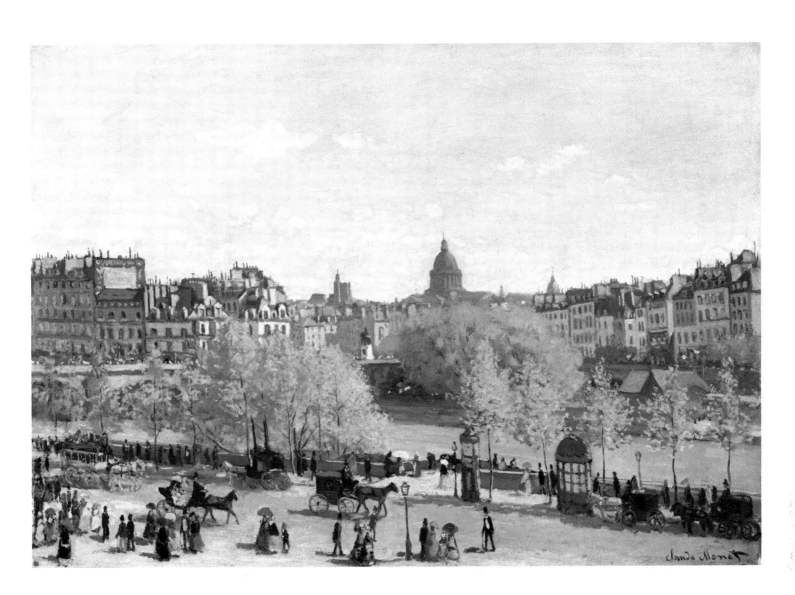

Terrace at Sainte-Adresse

OIL ON CANVAS, 98 x 130 CM. 1867. NEW YORK, THE METROPOLITAN MUSEUM OF ART

Terrace at Sainte-Adresse shows Monet's father and aunt, with his cousin and a male friend beyond, on a terrace overlooking the sea at Sainte-Adresse. In place of the peasant types of his first Sainte-Adresse seascapes (see Plate 1), the sea is now the backdrop for a group of fashionable figures, at leisure in a well tended garden. Compared with the measured recessions characteristic of contemporary landscapes, the grid-like composition and high viewpoint of *Terrace at Sainte-Adresse* were intended to seem shocking, and they were an early attempt to harness the lessons of Japanese colour prints; Hokusai's *Travellers Viewing Mount Fuji* (Fig. 18), a print from a series in circulation in Paris during the 1860s, shows similar devices. Particularly unexpected in Monet's canvas is the way in which the woman's head in the foreground is entirely masked by the decisive shape of her parasol. Novel too were the clear contrasting colours that dominate the scene, used to pick out the varied hues of flowers, foliage, sea and flags in the sunlight.

Fig. 18 **Hokusai** (1760–1849): Travellers Viewing Mount Fuji

FROM 'THE THIRTY-SIX VIEWS OF MOUNT FUJI'. WOODBLOCK PRINT

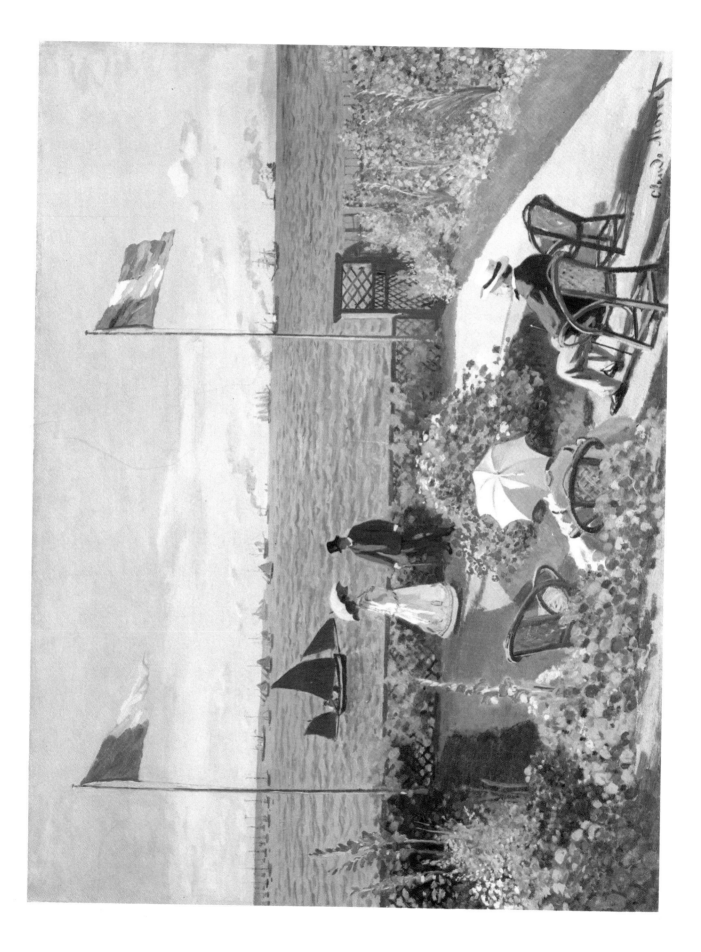

The River

OIL ON CANVAS, 81 x 100 CM. 1868. THE ART INSTITUTE OF CHICAGO

Decisively painted in bold, simple zones and dabs of colour, *The River* shows Monet's vision of the later 1860s at its most direct. The patterns of light and shade, and the buildings with their reflections, are captured with an immediacy untempered by refinements of texture or coloured nuance. The picture is one of the first in which Monet explored the effects of reflections in water, which became a central motif in his later work, but here the reflections are seen still and whole, not fragmented by ripples (compare Plates 9, 11, 16, 23, 42, etc.).

The view shows the village of Bennecourt, located half way between Paris and Rouen on the Seine, seen from an island in the river, on which Camille (see Plate 3) is seated. Monet stayed there for a spell in the early summer of 1868, probably on the recommendation of the novelist Zola, who had himself stayed there with Cézanne in 1866. Fifteen years later, Monet was to settle in the nearby village of Giverny (see Plate 31).

Detail from 'Luncheon'

OIL ON CANVAS, 230 x 150 CM. 1868. FRANKFURT, STÄDELSCHES KUNSTINSTITUT

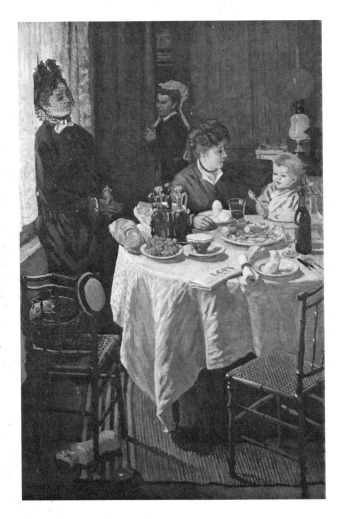

Luncheon was painted while Monet was living at Etretat in the winter of 1868–9 with Camille and their son Jean (born in 1867). Its size, elaborate composition and high degree of finish mark it out as an ambitious painting, and it was rejected by the jury at the 1870 Salon. Four years later, it was the only large canvas which Monet chose to include in the first Impressionist group exhibition of 1874.

On one level, the canvas is a 'slice of life': a caller stands by the window, Camille feeds Jean, the foreground place awaits the master of the household, Monet himself. But this apparent informality is the result of careful planning; it is conveyed by the multiple focuses and cut off forms in the composition, and by the crisp gestures of the brush, reminiscent of Manet, which define its components. Many elements — the loaf of bread, the newspaper, the novels on the back table — overlap the edges of their supports, to heighten this sense of immediacy, while the clear lighting brings the spread on the table to life. Rarely, except in the art of Chardin, has an everyday meal become such a sumptuous display.

Fig. 19 (left)
Luncheon

OIL ON CANVAS, 230 x 150 CM. 1868. FRANKFURT, STÄDELSCHES
KUNSTINSTITUT

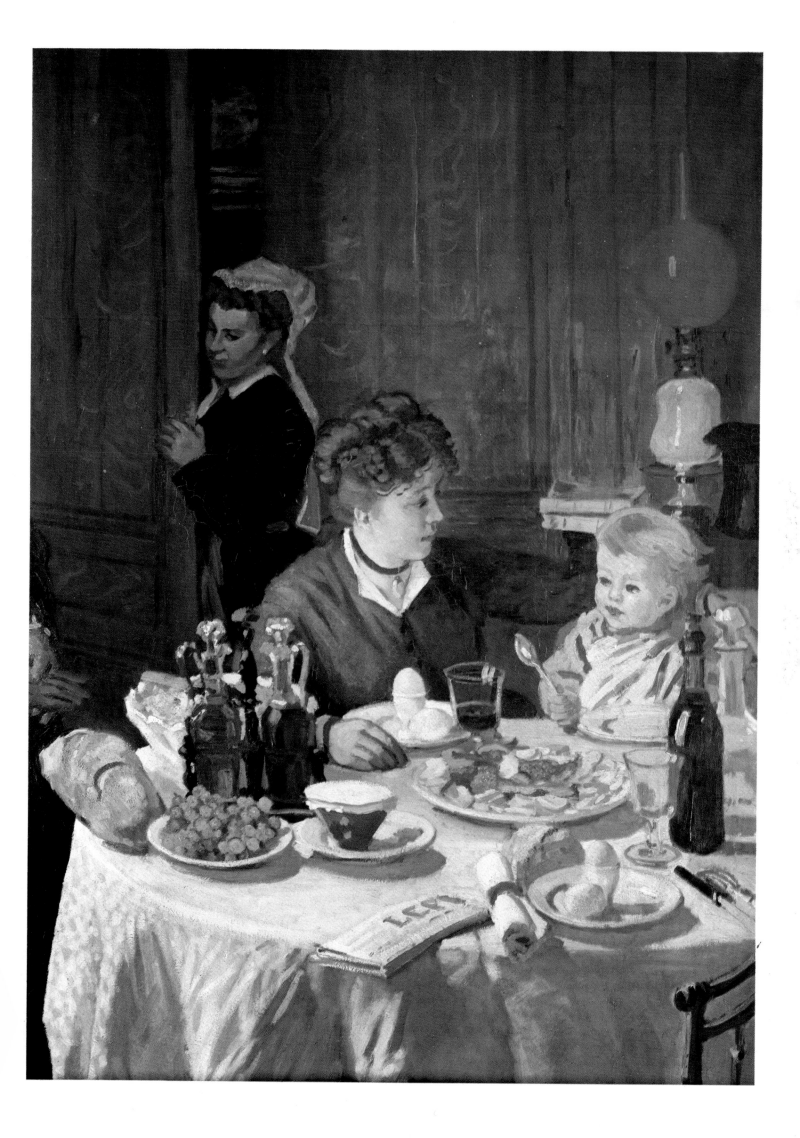

The Red Cape

OIL ON CANVAS, 100 x 80 CM. 1868-9. CLEVELAND, MUSEUM OF ART.

The Red Cape was probably painted at Etretat in the winter of 1868–9, at about the same time as *Luncheon* (Plate 7). However, the two paintings are very different: *The Red Cape* is not a finished exhibition picture; it is smaller and far more broadly handled, with the forms suggested by simple sweeps of paint. Like *Luncheon*, though, it focuses on a fleeting moment — here, the most transitory of gestures: Camille glances through the window as she passes by, walking through the snowy garden. The empty interior stands in poignant contrast to the figure beyond, whose red cape — the focus of the whole composition — is pushed into the middle distance by the cool toned grid of the window frame. This canvas evidently had a special meaning for Monet: it was one of the very few of his early works that he kept with him throughout his life.

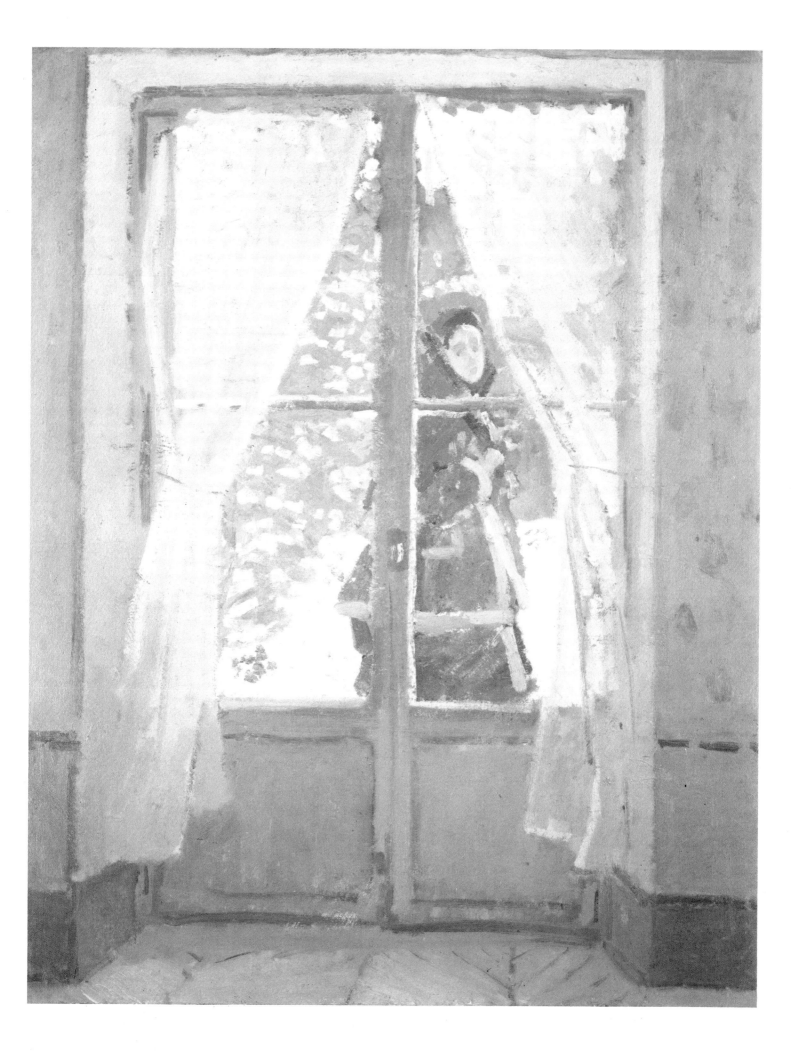

La Grenouillère

OIL ON CANVAS, 75 x 100 CM. 1869. NEW YORK, THE METROPOLITAN MUSEUM OF ART

During the summer of 1869, Monet and Renoir painted together on the Ile de Croissy, in the Seine near Bougival downstream from Paris. Both men were planning exhibition pictures for the next year's Salon of the bathing and boating establishment there, known as La Grenouillère. In the event, Renoir never painted the place on a large scale; Monet did, but the canvas that was probably submitted to the 1870 Salon is now lost.

Their surviving canvases of La Grenouillère are only studies for this project — Monet described his (Plate 9 and Fig. 20) as 'bad sketches'. However, the subject allowed both men to paint natural effects, and particularly water surfaces, with a new freedom. Monet translated the reflections in the slow moving ripples of the foreground of La Grenouillère into startling bands of contrasting colours and tones. During the next five years, he was to incorporate much of the freedom shown in his La Grenouillère studies into his more fully finished canvases (see Plates 13 and 16).

Fig. 20 (right)
La Grenouillère

OIL ON CANVAS, 73 x 92 CM. 1869. LONDON, NATIONAL GALLERY

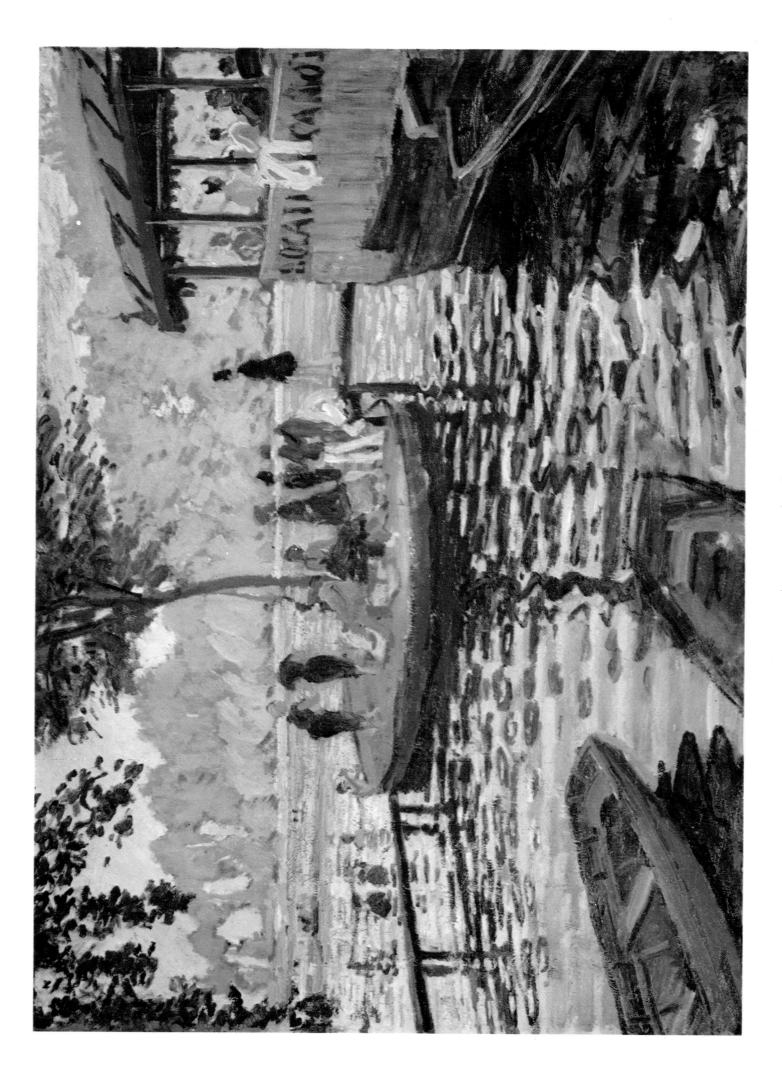

Road at Louveciennes in the Snow

OIL ON CANVAS, 55 x 65 CM. 1869–70. PRIVATE COLLECTION

Painted during the winter of 1869–70, *Road at Louveciennes in the Snow* shows a quite different facet of Monet's work from the sketches painted at nearby La Grenouillère during the previous summer (see Plate 9). Though smaller than them, it is a fully finished picture, and its varied yet delicate handling shows how, by this date, Monet was able to use the brush with complete assurance to evoke the textures of natural objects of very many sorts. This varied touch within the same painting, used as a shorthand for the variety of nature, was mastered also by Pissarro and Sisley at just the same moment (see Fig. 21),

and became one of the prime characteristics of early Impressionist painting. Both men were working at Louveciennes during this same winter, and Pissarro painted exactly the same stretch of road as Monet – in rain, not under snow (Sterling and Francine Clark Art Institute, Williamstown, Mass.).

Space and atmosphere in Monet's canvas are expressed by soft nuances of colour within a dominantly tonal framework, in contrast to the bolder zones of colour of his earlier sunlit scenes (see Plates 5, 6 and 9).

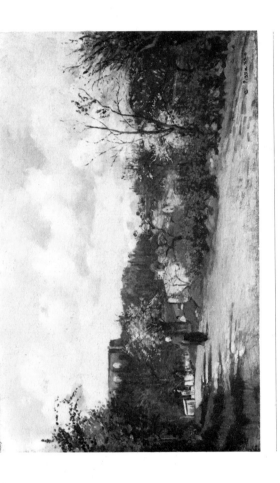

Fig. 21 **Camille Pissarro** (1830–1903): View from Louveciennes

OIL ON CANVAS, 52.5 x 82 CM. C.1870. LONDON, NATIONAL GALLERY

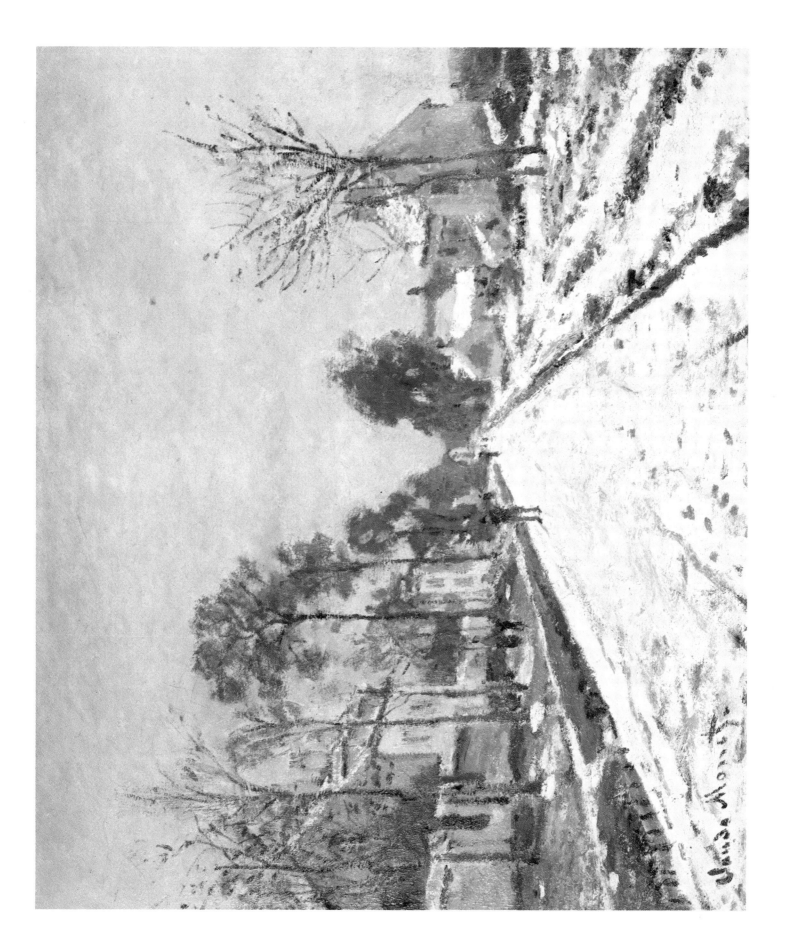

The Thames and the Houses of Parliament

OIL ON CANVAS, 47 x 73 CM. 1870–1. LONDON, NATIONAL GALLERY

The Thames and the Houses of Parliament is one of the first canvases in which Monet treated the effects of mist and fog, later to become so important in his work, as a means of giving his paintings an overall atmospheric unity (see Plates 15, 24, 37, 41–2). Here, sky and water are treated in delicate nuances of greys, yellows and pinks, set off against the veiled silhouette of the Houses of Parliament and the crisp forms of the landing-stage in the foreground. The paint surfaces are applied with great economy and with a simplicity perhaps reminiscent of Whistler, who was at this time painting his first *Nocturnes* on the Thames (see Fig. 22). However, the precision of its forms shows that *The Thames and the Houses of Parliament* was intended as a fully finished picture in its own right, in contrast with rapid sketches such as *Impression, Sunrise* of 1872 (Plate 15, and see note on Plate 14).

When Monet painted this scene, all of its elements had only recently been constructed – the Houses of Parliament, the new Westminster Bridge, Victoria Embankment, and St Thomas's Hospital (seen in the distance on the left). What now seems to us an image of the traditional heart of London would, in 1871, have been the prime example of urban reconstruction in London, and London's only equivalent to the recent monumentalization of Paris by Baron Haussmann.

Fig. 22 **James Whistler** (1834–1903): Nocturne in Blue and Green: Chelsea

OIL ON CANVAS, 48 x 60 CM. 1871. LONDON, TATE GALLERY

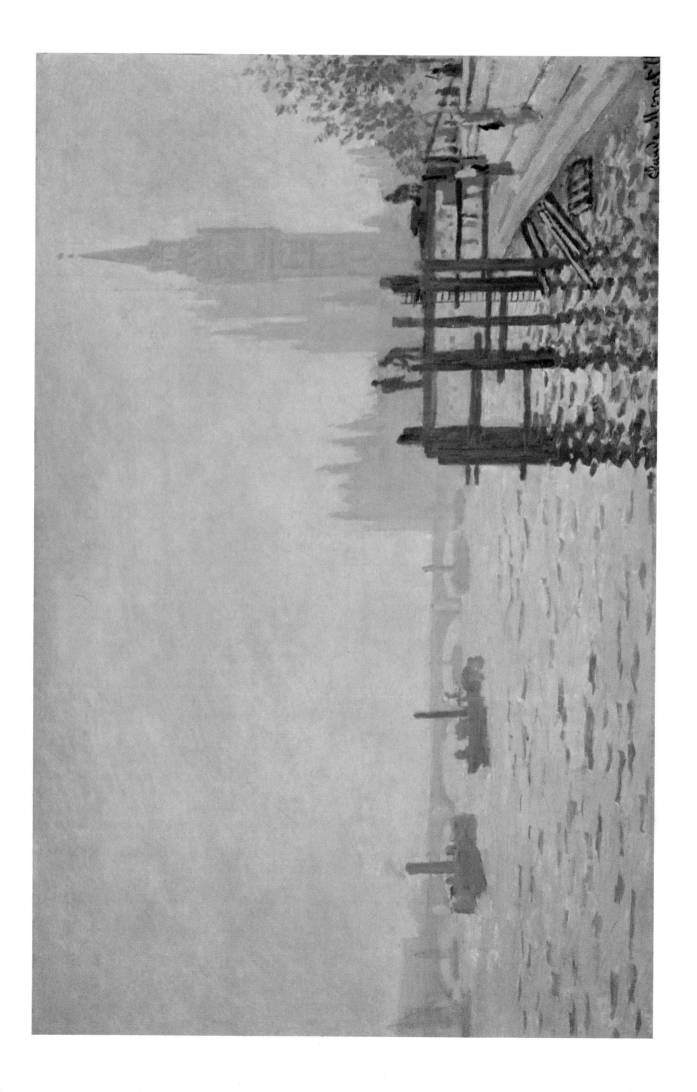

Green Park

OIL ON CANVAS, 34 x 72 CM. 1870–1. PHILADELPHIA MUSEUM OF ART

Green Park, like *The Thames and the Houses of Parliament* (Plate 11), was painted during Monet's refuge in London from the Franco-Prussian War. It shows the park looking towards the west with the rooftops of Piccadilly on the right, and, in the misty background, the silhouette of the equestrian statue of the Duke of Wellington on top of the Constitution Arch, from which it was removed when the Arch was moved to its present position in 1883.

Scenes of London's parks are very rare in Victorian painting, and such themes were never treated in England with the detachment and avoidance of psychological content of *Green Park*. The roots of this dispassionate vision are French — in the topographical prints of the time (see Plate 4), and in the ideas of Baudelaire's essay *The Painter of Modern Life* (published in 1863). However, *Green Park* is full of acute social observation of the characteristic types who frequented the place, deftly captured with a few strokes of the brush, down to the tiny figures of the nursemaids accompanying their charges on the path to the right. Manet had adopted a similar vision in paintings such as his panorama of the 1867 Exposition Universelle (Fig. 23).

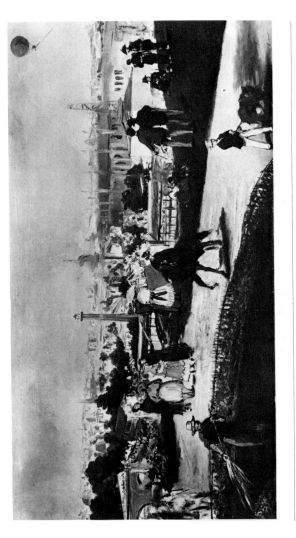

Fig. 23 **Edouard Manet** (1832–83): View of the Exposition Universelle

OIL ON CANVAS, 108 x 196.5 CM. 1867. OSLO, NATIONAL GALLERY

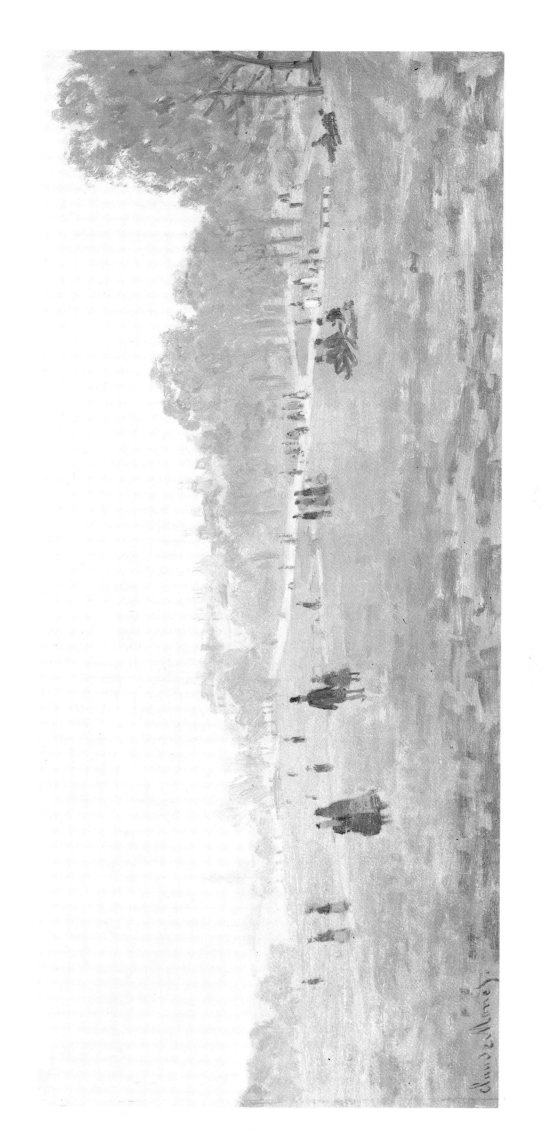

The Port of Zaandam

OIL ON CANVAS, 47 x 74 CM. 1871. PRIVATE COLLECTION

The Port of Zaandam was painted during Monet's five-month stay in Holland on his way back from London to France in 1871. Zaandam, situated on the river Zaan to the north west of Amsterdam, was then still a picturesque centre of local commerce. Monet focused on the old houses of its waterfronts, and on the windmill-studded open panoramas of the surrounding countryside, as in *Mills near Zaandam* (Fig. 24).

In *The Port of Zaandam* strong tonal contrasts convey the *contre-jour* sunset; the rich colours of the sky are picked up in the bold slabs of paint, reminiscent of the foreground reflections. The structure of *La Grenouillère* (Plate 9), which define the foreground reflections. The structure of the painting is tautly organised, with a counterpoint between the delicate lines of the masts with their flags and the massive wooden structure in the water; this, with its reflection, becomes a bold shape on the canvas surface.

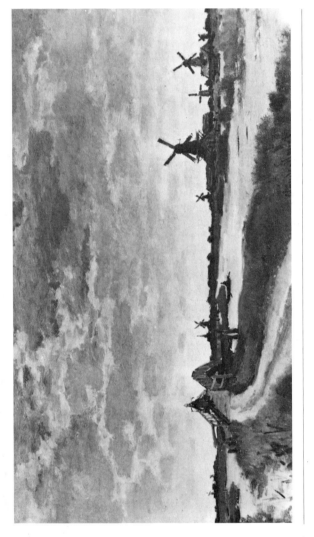

Fig. 24 Mills near Zaandam

OIL ON CANVAS, 40 x 72 CM. 1871. BALTIMORE, WALTERS ART GALLERY

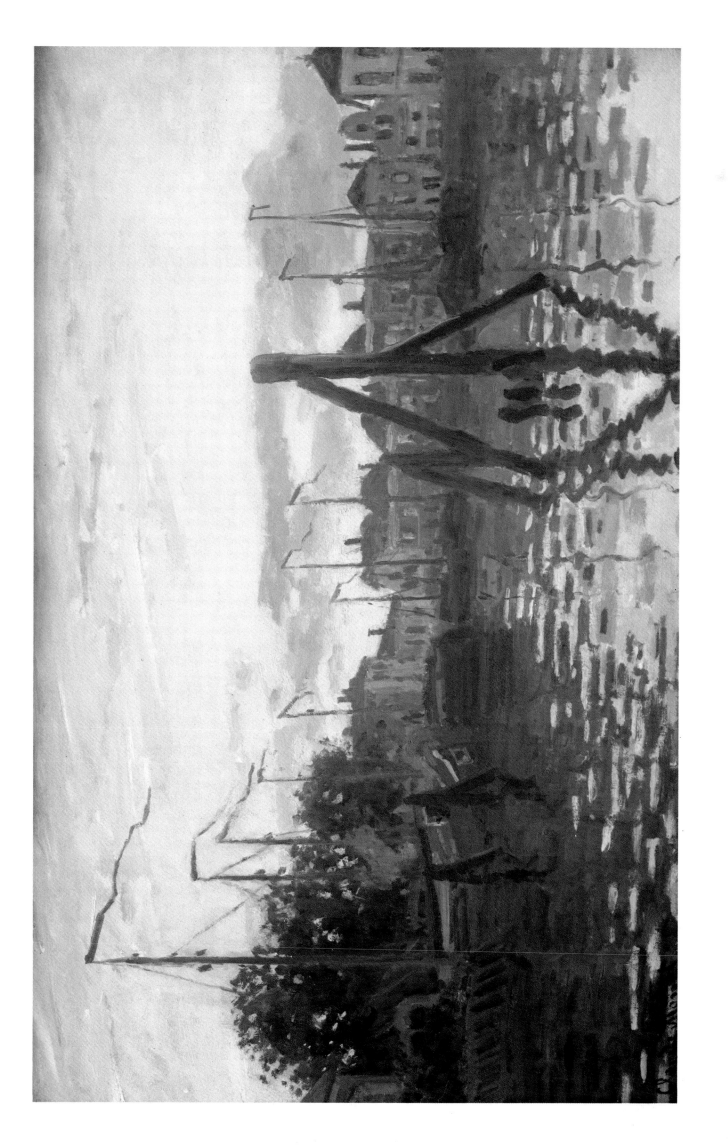

The Riverside Walk at Argenteuil

OIL ON CANVAS, 50.5 x 65 CM. 1872. WASHINGTON, D.C., NATIONAL GALLERY OF ART

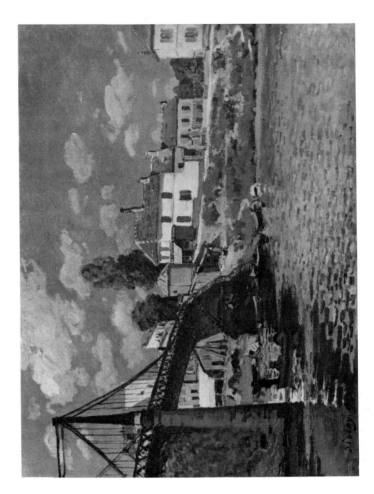

On his return to France at the end of 1871, Monet settled at Argenteuil, a town on the Seine a short distance downstream from Paris. At the time, Argenteuil was a centre for boating and suburban recreation, but parts of the place were also becoming industrialized. *The Riverside Walk at Argenteuil* shows these different facets of the place, in the boats, the smart villa and the factory chimneys. However, Monet is at pains not to pass judgement on the elements in the scene: the vertical accents of sails, chimneys, trees and the spirelet on the house are all given equal weight in the composition, as each is an equally integral part of the scene before him.

The Riverside Walk at Argenteuil, though quite a small canvas, is meticulously executed, its forms crisply and clearly defined; moreover, its composition is quite traditional, with a strongly receding perspective leading into the picture. Only in the modernity of its subject and in the clarity of its lighting does it stand out from the river scenes of landscapists of the previous generation such as Daubigny. During the same summer, Sisley, too, was painting the villages of the Seine with similarly crisp yet varied brushwork (see Fig. 25). Monet's and Sisley's paintings are examples of the sort of pictures that they were selling to dealers such as Paul Durand-Ruel in the early 1870s — fully finished canvases, in contrast to the rapid sketches that gave Impressionism its early notoriety (see Plate 15).

Fig. 25
Alfred Sisley (1839–99): The Bridge at Villeneuve-la-Garenne

OIL ON CANVAS, 49.5 x 65.5 CM. 1872. NEW YORK, THE METROPOLITAN MUSEUM
OF ART, GIFT OF MR AND MRS HENRY ITTLESON JR., 1964

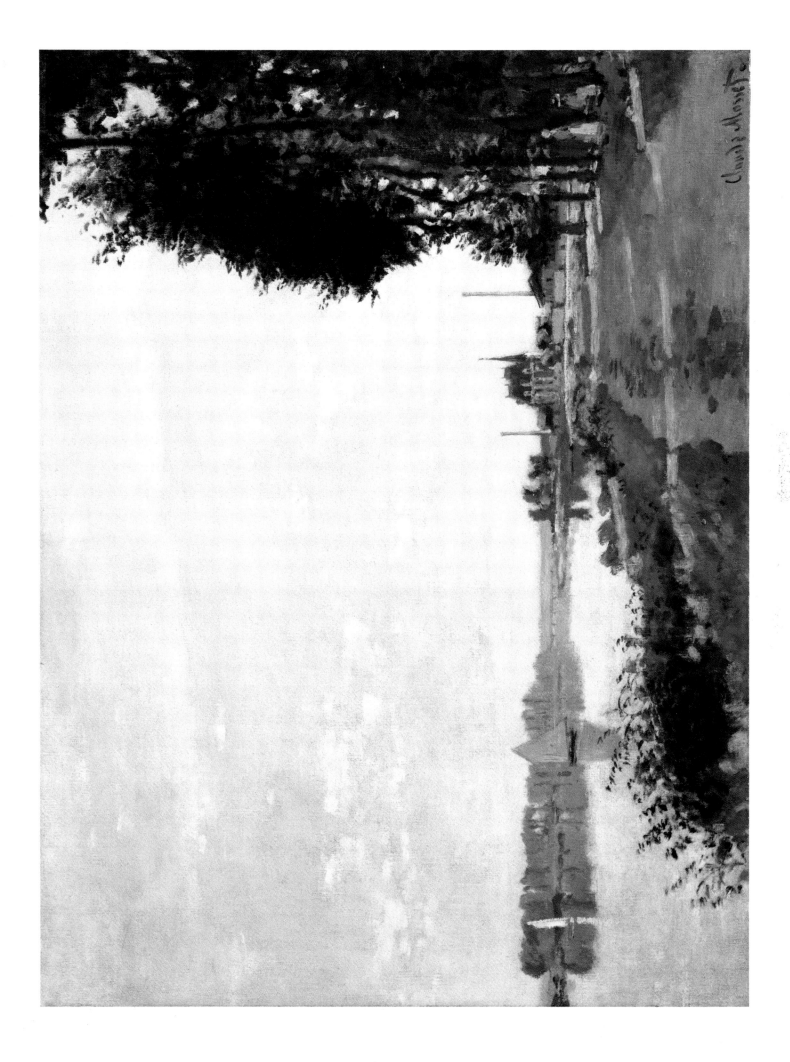

15

Impression, Sunrise

OIL ON CANVAS, 48 x 63 CM. 1872. PARIS, MUSÉE MARMOTTAN

Impression, Sunrise was shown in the group exhibition organized by Monet and his friends in spring 1874. The critic Louis Leroy picked on its title, and christened the whole group 'Impressionists'. This name has stuck, though the artists themselves never endorsed it wholeheartedly. The picture shows the port of Le Havre in the mist. It was clearly executed very rapidly, laid in with broad sweeps of colour which sum up the whole effect without any recourse to detail. In this respect it is untypical of most of Monet's work of the time (see Plate 14), and Monet later said that he had called it *Impression* because 'it could not pass for a view of Le Havre', thus distinguishing it from the other, more topographical, open air scenes that he exhibited with it in 1874, such as *The Boulevard des Capucines* (Fig. 7; Plate 7 was also included in this show). The term 'impression' was already widely used at this date to refer to sketches of fleeting effects of light and atmosphere. Sketches such as this were an important part of Monet's repertoire in the 1870s, but they do not sum up his art and that of his colleagues from these years. They have to be considered in relation to their more elaborated canvases; the painters always took care to exhibit their sketches alongside more finished works (see also Plates 22 and 24).

Autumn at Argenteuil

OIL ON CANVAS, 56 x 75 CM. 1873. LONDON, COURTAULD INSTITUTE GALLERIES

Rich, sunlit effects first encouraged Monet to lighten and brighten his colour (see Plate 5). In *Autumn at Argenteuil* of 1873 he has virtually abandoned the contrasts of dark and light tones which had predominated in even such recent canvases as *The Riverside Walk at Argenteuil* (Plate 14); instead, light and atmosphere are conveyed by a play of lavish, high key colour. Within a dominant contrast of blues and oranges, delicate nuances of pinks, greens and other hues are introduced. Distance is suggested not by orthodox perspective, but by atmospheric colour and by the diminishing scale of touches in the water. Unusually in a painting by Monet, scratch-marks, probably made with the brush-handle, appear in the thick paint-layers of the foliage, more prominently on the right hand tree. Monet may have made these marks to enliven the effect of the trees, which are treated with a density of paint uncommon in his work at this period (contrast Plate 17 and Plate 37). The subject shows the village of Argenteuil seen from a backwater of the Seine, looking out over the main stream of the river. The house with a spire, to the left of the church, is seen from different angles in Plates 14 and 20.

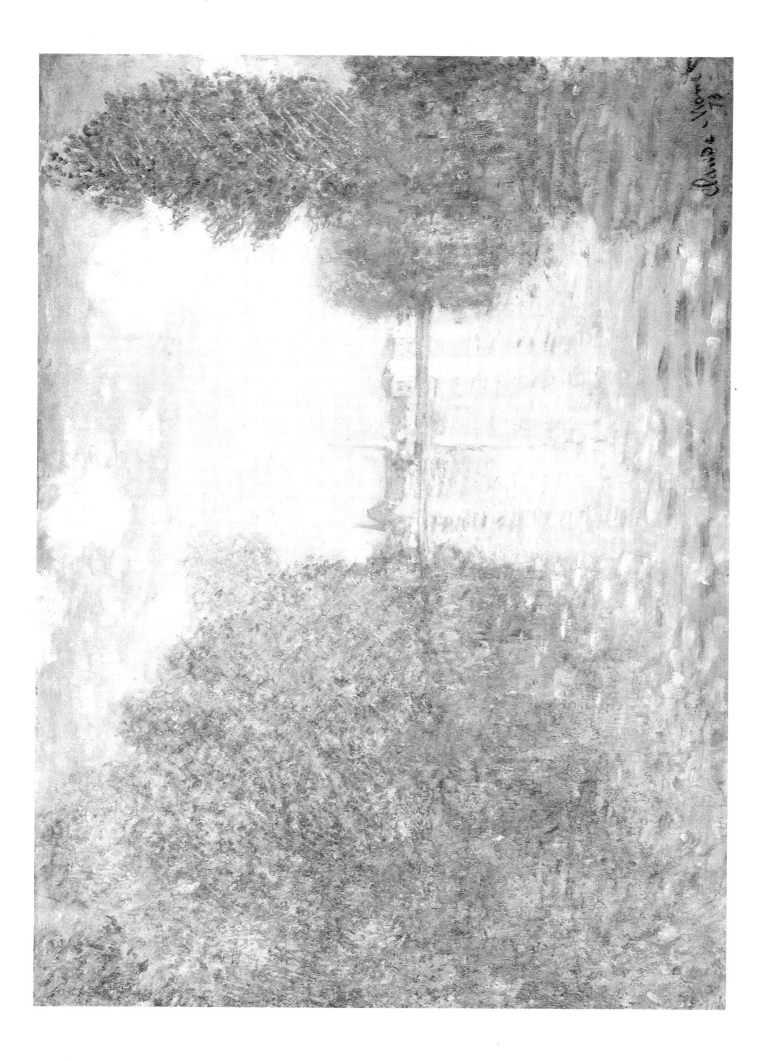

Summer, the Meadow

OIL ON CANVAS, 57 x 80 CM. 1874. BERLIN, NATIONALGALERIE, STAATLICHE MUSEEN

Monet's paintings of the Argenteuil area vary greatly in handling, as he sought techniques that best suited the variety of natural effects before him (see Plates 16, 18 and 20). In *Summer, the Meadow* the treatment is fresh and extremely economical, the touch accentuated just enough to focus attention on the foreground and on the foliage of the young trees. Even the main figure is treated in simple patches of colour, defined no more precisely than any other elements in the scene. The composition of the painting complements the simplicity of its handling. Trees and figures are spread informally across the surface, while the placing of the two tall trees unobtrusively focuses attention on the seated woman. No defined perspective leads into space. Distance is suggested by the soft blues of the background, while light greens and yellows convey the sunlit field and trees. Compare the much more elaborated rendering of a similar theme in *Spring* of 1886 (Plate 31).

Summer, the Meadow was shown in the second Impressionist exhibition in 1876.

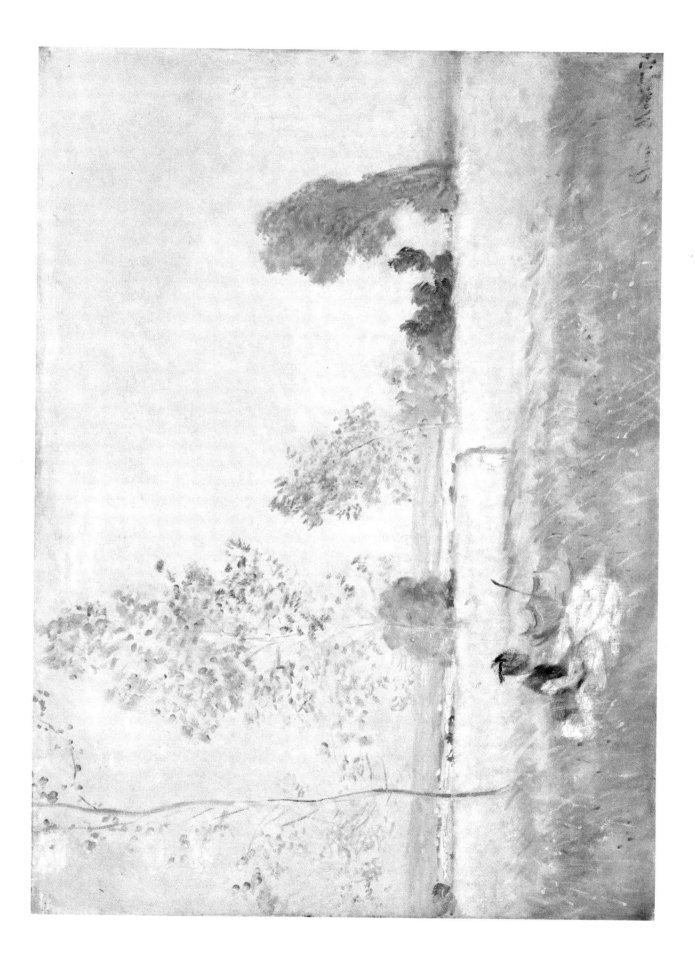

The Road-Bridge at Argenteuil

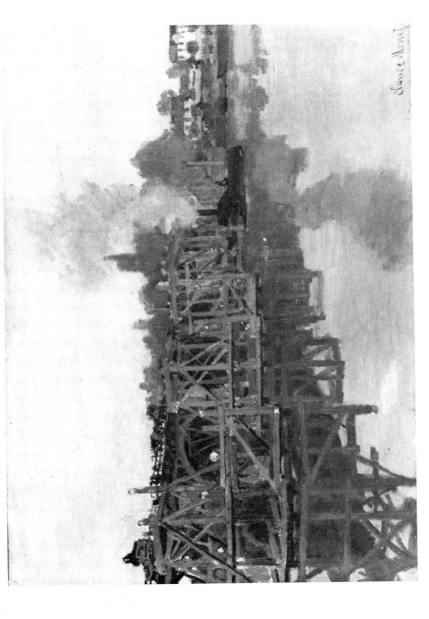
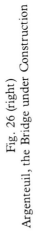

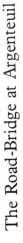

The river with its sailing boats was one of Monet's favourite themes at Argenteuil (see Plates 14 and 20). In some pictures the bridges across the river give the scene a strong architectural structure, contrasted in *The Road Bridge at Argenteuil* with the more delicate lines of masts and rigging, which create an elaborate mesh of lines across the open zone of water, and frame the house in the trees on the far bank with two strong verticals.

The broken accents in the water contrast with the softer, less accentuated touches used in the background. Blues appear in the shadows on the bridge and in the far trees, serving as cool accents, which are set off against the warmer hues in the sunlit areas and reflected on to the underside of the bridge.

Monet had first painted the Argenteuil road bridge while it was being rebuilt in 1872 after its destruction in the Franco-Prussian war (see Fig. 26).

Fig. 26 (right)
Argenteuil, the Bridge under Construction

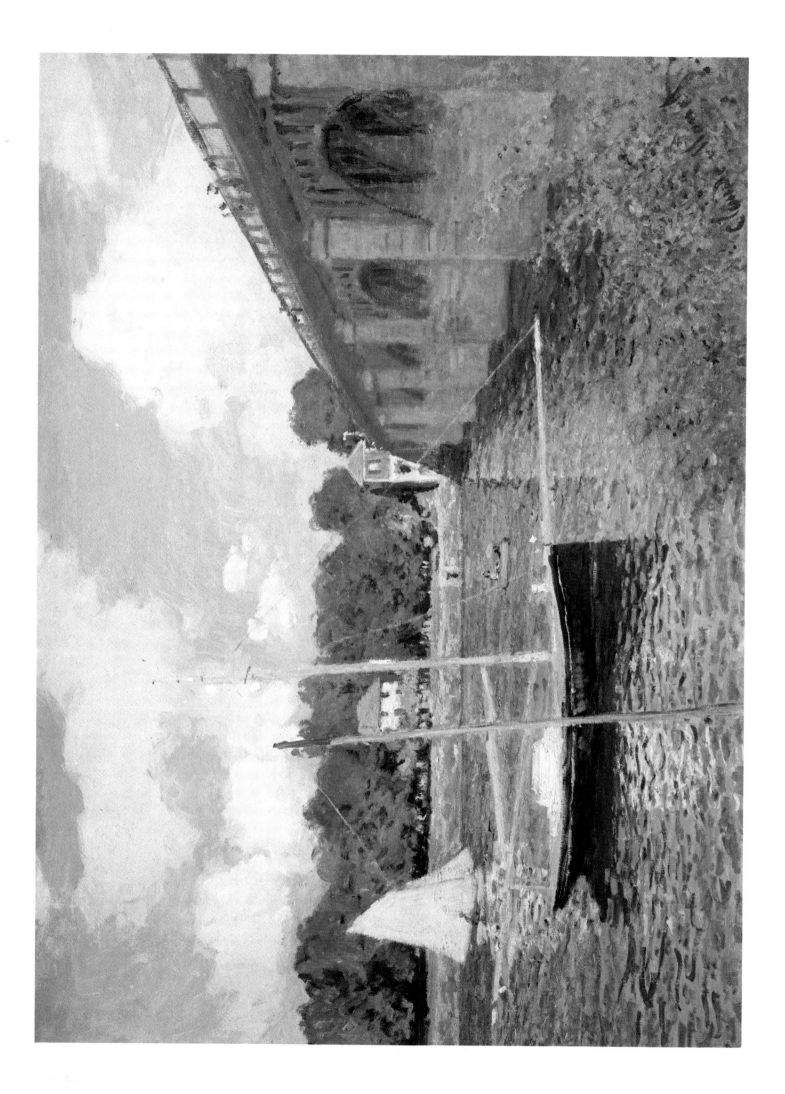

The Zuiderkerk, Amsterdam

OIL ON CANVAS, 54.5 x 65.5 CM. C.1874. PHILADELPHIA MUSEUM OF ART

The Zuiderkerk, Amsterdam belongs to a group of paintings of Amsterdam that Monet painted on a second visit to Holland. Puzzlingly, no evidence has come to light that helps date this visit. The Amsterdam paintings clearly postdate those of Zaandam of 1871 (see Plate 13): their brushwork is more fragmented and flecky, their surfaces more consistently broken in texture; and they are lighter and clearer in colour. On stylistic grounds, the canvases belong around 1874, but the visit cannot be securely fitted into the framework of what we know of Monet's life at this time.

In Amsterdam, Monet painted principally on the canals of the old town, with its towers and canal-side houses, subjects that belong to the tradition of topographical painting so common in Holland since the seventeenth century. However, instead of focusing on the details of the buildings, Monet treated the whole scene in a network of small touches, to convey the light which unified the scene. His favoured subjects in Holland, like those from the same period in France, are man-made: throughout the 1870s, he concentrated primarily on towns and villages, in contrast to the more dramatic unpeopled scenes that dominate his work of the 1880s (see Plates 32, 33 and 36).

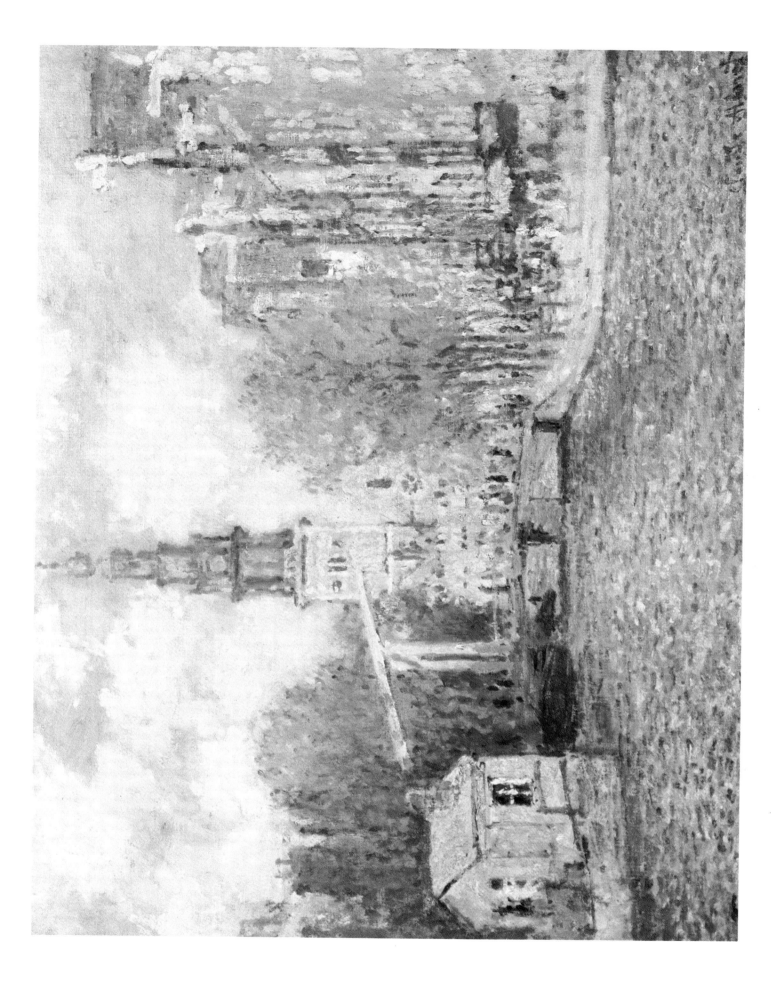

The Red Boats, Argenteuil

OIL ON CANVAS, 55 x 65 CM. C.1875. PARIS, MUSÉE DU LOUVRE (COLLECTION JEAN WALTER – PAUL GUILLAUME)

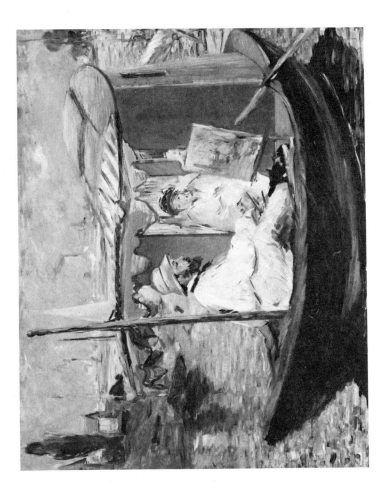

In *The Red Boats, Argenteuil* Monet conveyed the shimmering light of a summer day by treating large parts of the painting in broken touches and flecks of paint. Even boats and sky are enlivened by delicate changes of texture. The colour, too, is variegated throughout, in place of the simpler and broader colour zones characteristic of the earlier 1870s (see Plate 14). In the trees, the transition from light to shade is expressed by gradations from yellows and yellow-greens through greens to soft yet clear blues; these blues are picked up in the water reflections, to create a sequence of denser, cooler tones across the picture, set off against the dominant luminosity and the strong orange-reds of roofs and boats.

In 1874, Manet painted Monet working on his studio-boat (Fig. 27), set against the same background as that in *The Red Boats*. Monet had acquired this boat around 1873, to facilitate his pursuit of outdoor effects (see Fig. 6). Factory chimneys appear on the horizon in Manet's picture, as they do in Monet's *The Riverside Walk at Argenteuil* (Plate 14), which shows the same stretch of the river, from the opposite bank. However, he omitted them from *The Red Boats*, perhaps wanting to stress a more idyllic mood in this scene of recreation and boating.

Fig. 27 (right)

Edouard Manet (1832–83): Monet Painting on his Studio Boat

OIL ON CANVAS, 80 x 100 CM. 1874. MUNICH, BAYERISCHE STAATSGEMÄLDESAMMLUNGEN

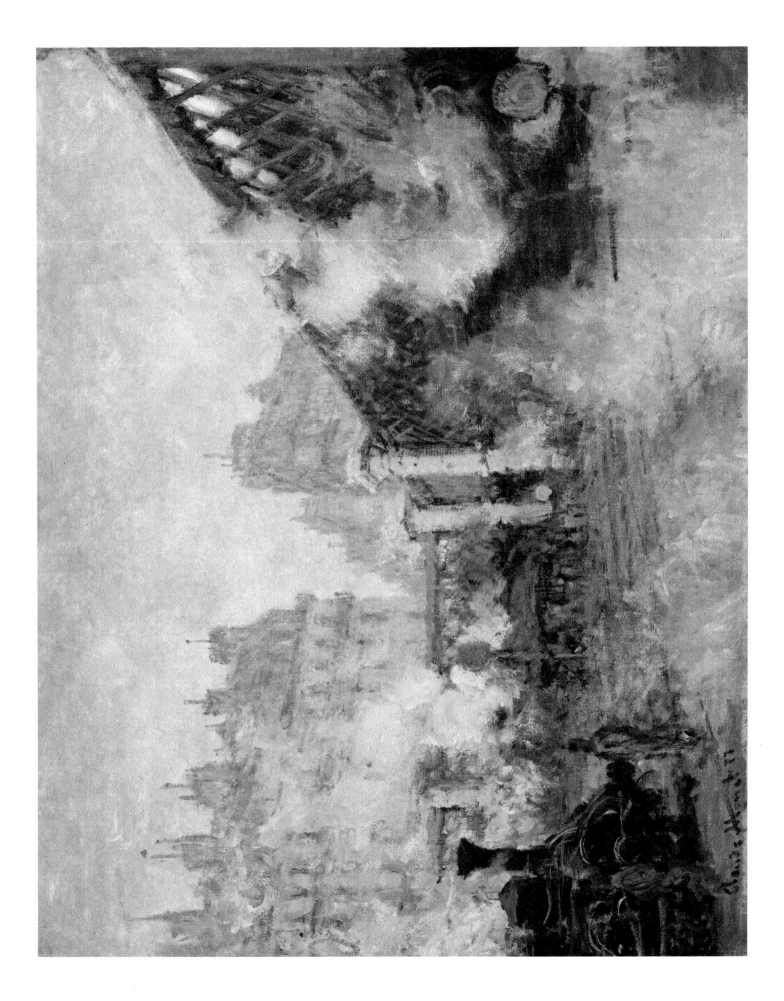

Vétheuil Church

OIL ON CANVAS, 51 x 61 CM. C.1879. SOUTHAMPTON, CITY ART GALLERY

In contrast to the developing suburban landscape of Argenteuil, Vétheuil was a small, rural village on the Seine, dominated by its old church. Monet painted the place from many angles while living there between 1878 and 1881. Sometimes, as in *Vétheuil Church* and *Vétheuil in the Fog* (Plate 24), the village is seen from Monet's studio boat, with the church as its focus; sometimes it is viewed from a greater distance, from the village of Lavacourt on the opposite bank of the Seine, sometimes from one of the islands in the river, as in *The Hills of Vétheuil*, in which Monet's studio-boat is shown moored by the riverbank, below the house in which he lived (Fig. 30).

Vétheuil Church shows one of Monet's favourite compositional formats — the subject seen frontally across water, balanced by its reflection in the lower half of the picture (see Plates 16 and 42). The eye enters the picture-space across the water, but at the same time the rhymes between the shapes of buildings and reflections give a two-dimensional coherence to the picture.

Fig. 30 (right)
The Hills of Vétheuil

OIL ON CANVAS, 61 x 99 CM. 1880. PRIVATE COLLECTION

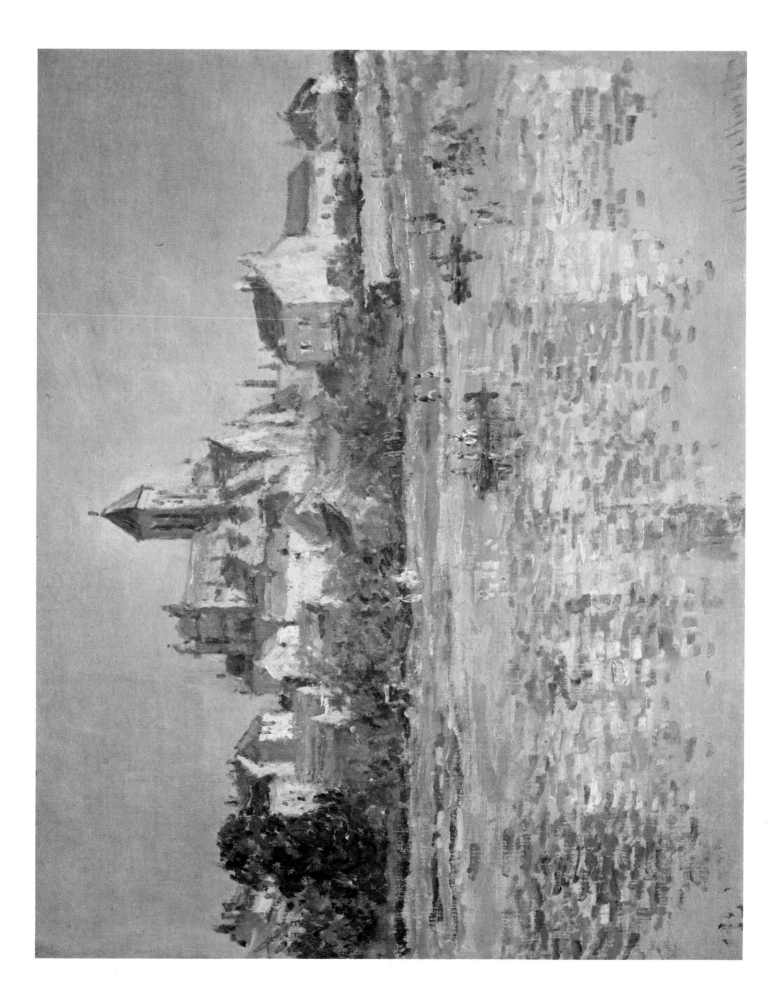

Vétheuil in the Fog

OIL ON CANVAS, 60 x 71 CM. 1879. PARIS, MUSÉE MARMOTTAN

Monet had previously painted mists (see Plates 11 and 15), but *Vétheuil in the Fog* was his first attempt to capture a subject whose forms were virtually dematerialized by fog. He later described how he had waited in his studio-boat for the mists to lift and unveil his subject for long enough for him to paint it. His memory of this effect, of forms emerging and then disappearing in the mist, was one of the stimuli that, ten years later, was to lead him to work in series of canvases of changing atmospheric conditions (see Plates 37 and following). Even in 1879–80, he treated this same view several times (see Plate 23), but he did not see these paintings as a close knit group in themselves.

Vétheuil in the Fog was rejected by one of Monet's principal patrons, the singer Faure, because it 'did not have enough paint on it'; thereafter Monet kept the canvas, and exhibited it on several occasions in the later 1880s as a symbol for his quest after ephemeral effects. In 1887, he gave it the subtitle *Impression* to show that it was a rapid sketch of just such an effect (see Plate 15).

The Ice-Floes

OIL ON CANVAS, 97 x 150.5 CM. 1880. SHELBURNE, VERMONT, SHELBURNE MUSEUM

The winter of 1879–80 was exceptionally harsh, and early in January 1880 a sudden thaw sent massive blocks of ice floating down the Seine. Freeze and thaw alike presented Monet with a sequence of dramatic subjects, which encouraged him to resume work in earnest in the aftermath of the death of his wife Camille in September 1879. Some critics have seen these paintings as a direct expression of Monet's grief, but he never made such direct connections between nature and human emotions. He sought to express the moods that he found within nature (see also Plate 32), rather than imposing his own mental state on to what he saw. Indeed, while some of his paintings of the thaw emphasize the devastation that it brought, the scene in *The Ice-Floes* seems radiant and tranquil in the afternoon sunlight.

The large version of *The Ice-Floes* (Plate 25) was executed in Monet's studio directly from a smaller canvas of the identical effect (Fig. 31); it was painted for submission to the 1880 Salon, where it was rejected (see Plate 26). In making this studio enlargement for the Salon, Monet was returning to the practice that he had adopted for his first submissions to the Salon fifteen years earlier (see Plate 1).

Fig. 31
The Ice-Floes

OIL ON CANVAS, 61 x 100 CM. 1880. PARIS, MUSÉE DU LOUVRE, JEU DE PAUME

Lavacourt

OIL ON CANVAS, 100 x 150 CM. 1880. DALLAS, MUSEUM OF FINE ARTS

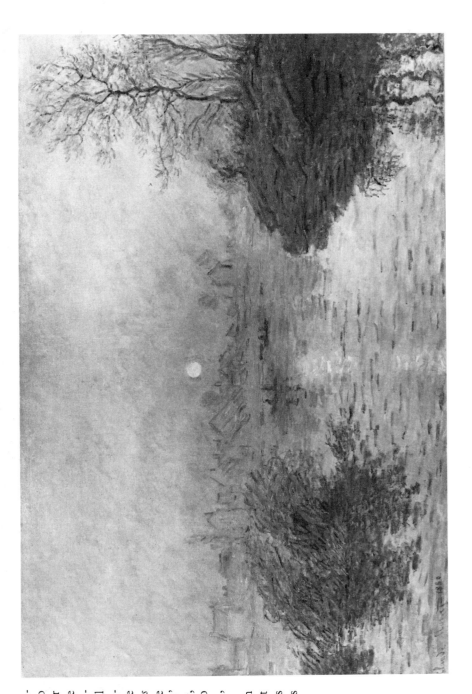

By 1880 Monet had become disillusioned with the results of the independently organized group exhibitions of the Impressionists, and decided to submit again to the official Salon, encouraged by the success that Renoir had won there the previous year. With this in view, he executed three comparatively large canvases, all painted in the studio from smaller outdoor works (see Plate 25 and Fig. 31). He felt that the Salon exhibition still demanded larger paintings than he had generally shown in the Impressionist exhibitions, and did not feel able to paint on the necessary scale directly in front of the subject. He planed initially to submit *The Ice-Floes* (Plate 25) and *Sunset on the Seine in Winter* (Fig. 32), but at a late stage decided that the latter was 'too much to my own personal taste' (presumably because of its similarity to the notorious *Impression, Sunrise*, Plate 15). So he executed a 'more judicious, more bourgeois' canvas to submit in its place, *Lavacourt*. In the event, only *Lavacourt* was accepted, and *The Ice-Floes* rejected.

Although *Lavacourt* presents Monet's favoured motif of a view seen across water (see Plate 23, etc.), it is handled more meticulously than most of his contemporary work. Its greens and soft blues create a luminous atmosphere, without the directness of lighting and brushwork of paintings such as *Vétheuil Church* (Plate 23).

Fig. 32

Sunset on the Seine in Winter

OIL ON CANVAS, 100 x 152 CM. 1880. PARIS, MUSÉE DU PETIT PALAIS

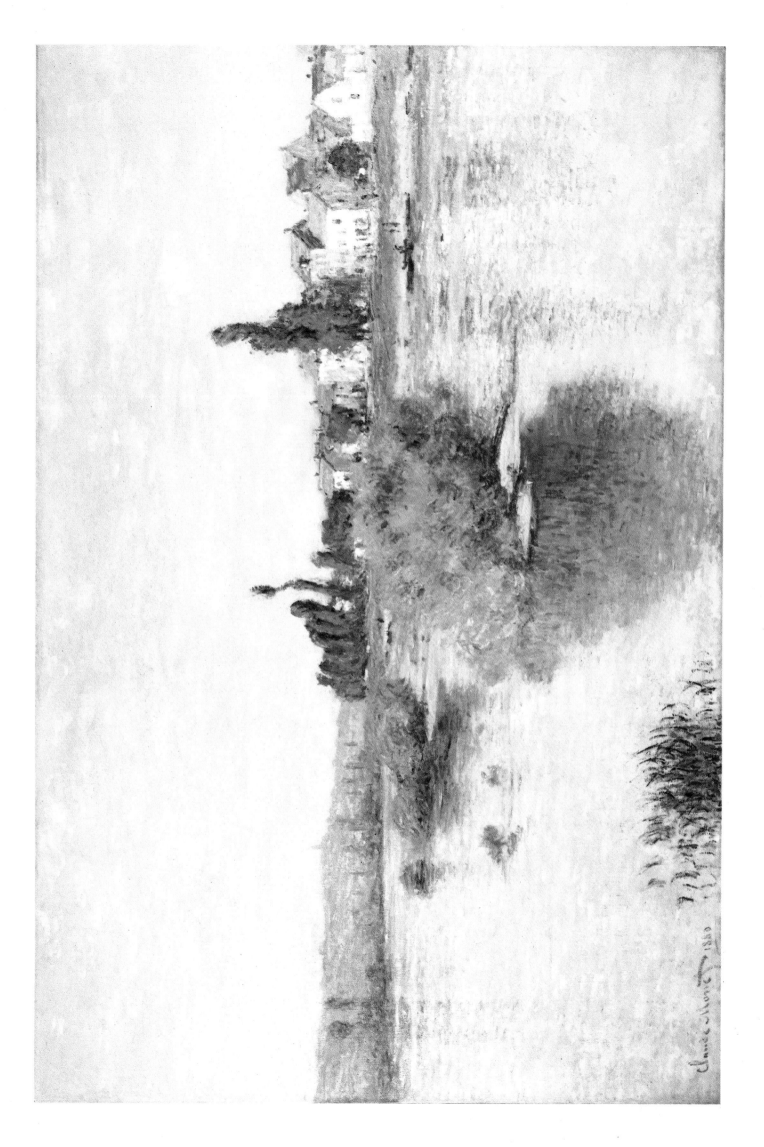

Pears and Grapes

OIL ON CANVAS, 65 x 81 CM. 1880. HAMBURG, KUNSTHALLE

Between 1878 and 1882, for the only time in his career, Monet gave considerable time to still life painting. Initially this may have allowed him to continue working when confined to the house by the last illness of his wife Camille, but even after her death in 1879 he continued to paint compositions of fruit, flowers or game, finding such work a suitable occupation for rainy days when he could not paint out of doors.

In the few still lives from his earlier career he had tended to present his subjects simply and frontally, looking for inspiration, like so many of his contemporaries, to the great French eighteenth-century still life painter, Chardin. However, in his fruit pieces of around 1880, such as *Pears and Grapes*, he viewed his subject diagonally and from above, allowing the loosely arranged groups of fruit to spread more freely up and across the canvas. In flower paintings such as *Chrysanthemums* (Fig. 33) the flower mass and the movement of stems and tabletop give the composition an overall movement. The lavishness and free flowing compositions of these still lives had an important influence on subsequent still life painting in France, both on the decorative arrangements of Gauguin and on van Gogh's dynamic groupings of flowers and fruit.

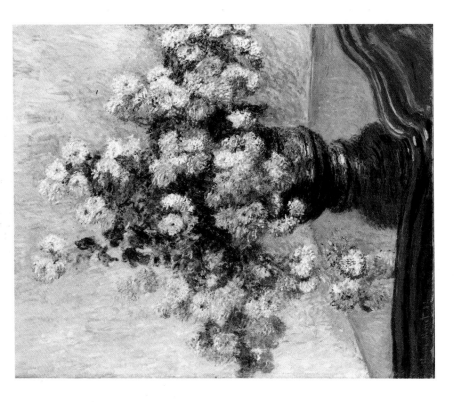

Fig. 33 (right)
Chrysanthemums

OIL ON CANVAS, 100 x 81 CM. 1882. NEW YORK, THE METROPOLITAN MUSEUM OF ART

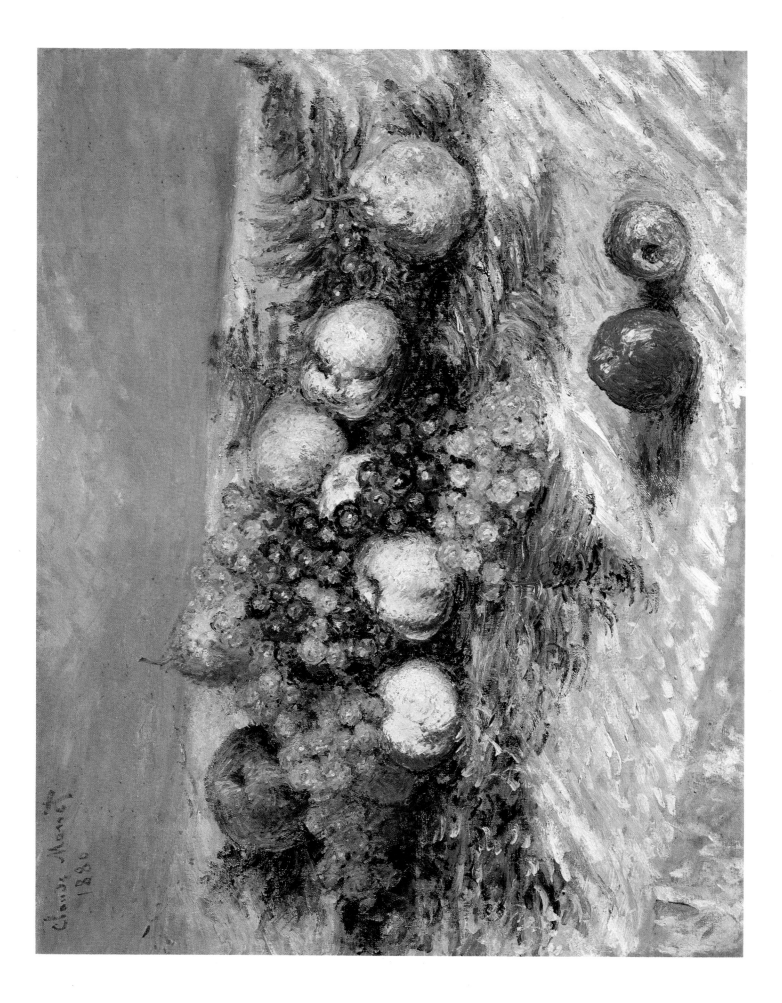

The Douanier's Cottage at Varengeville

OIL ON CANVAS, 60 x 73 CM. 1882, ROTTERDAM, MUSEUM BOYMANS-VAN BEUNINGEN

Monet's travels of the 1880s took him to places very different from the Seine valley, with its dominantly horizontal lines. He sought out rocky seacoasts and hills, and chose viewpoints that brought out the dramatic quality of his subjects, often emphasizing bold contrasts of space, shape and texture. In 1882, painting around Pourville and Varengeville to the west of Dieppe on the Normandy coast, he explored the local cliff scenery: one of his favoured subjects was a coastguard's cottage perched on the cliff edge above a narrow ravine running inland; he painted this cottage eighteen times in this year, in different weather conditions and from every possible angle, from above and below, silhouetted in many different ways against the cliff edge and the sea. However, though he treated the theme so many times, he never grouped these paintings together as a single series within his work. In Plate 28, the cottage is seen from the south east, across the ravine which lies beyond the foreground cliff area; in Fig. 34, from the south west, with the cliffs beyond Dieppe seen in the distance.

From 1881 onwards, Monet had for the first time a more or less regular market for his work, in the dealer Durand-Ruel, and later in the decade in other dealers (see Plate 34). This allowed him to work at his paintings for longer. Durand-Ruel was urging him to finish his paintings more fully, in response to the common criticism of the Impressionists during the 1870s, that they were too easily satisfied by rapid sketches. In Plate 28, the more broken textures of the foreground cliff, with its pockets of shadow, are set off against the sunlit hill-face beyond, which is constantly variegated in texture and colour, with soft pinks and oranges set off against greens, to produce a more consistently rich surface than in his typical paintings of the previous decade.

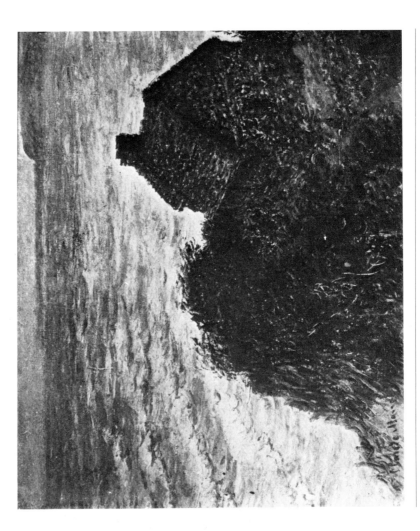

Fig. 34
The Douanier's Cottage

OIL ON CANVAS, 62 x 76 CM. 1882. CAMBRIDGE, MASSACHUSETTS, FOGG ART MUSEUM

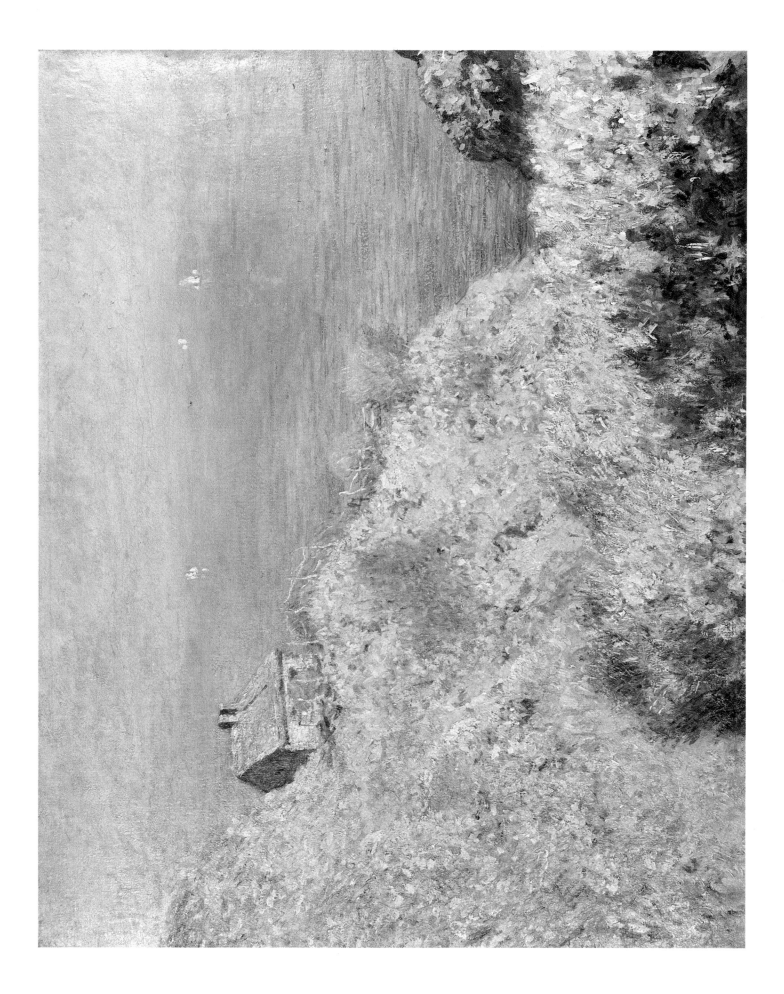

Varengeville Church

OIL ON CANVAS, 65 x 81 CM. 1882, THE UNIVERSITY OF BIRMINGHAM, BARBER INSTITUTE OF FINE ARTS

The dramatically asymmetrical composition and sumptuous sunset effect of *Varengeville Church* give the whole picture a great richness of pattern and colour. Like many of his clifftop scenes, it echoes the compositions favoured in Japanese landscape prints (see Fig. 9). Though Monet did not distort the natural subjects in front of him, such prints helped him to find ways of expressing the full effect of scenes such as this in pictorial form. The high viewpoint and overlapping planes, set diagonally, allow the viewer's eye to move into a deep space without the ordered perspectival recessions typical of the French classical landscape tradition. The sense of space is heightened by the contrast between the dynamic hooks of paint which describe the foreground foliage and the softer sweeps of colour on the hillside beyond.

At a late stage in painting *Varengeville Church*, Monet emphasized its lavish colour scheme, based on the contrast between the oranges and reds of the sunset and the blues and greens of the hillside. Elaboration such as this may well have been the product of the period of studio reworking which, by this date, Monet was finding increasingly necessary in order to finish his paintings. The boldness of the colour scheme foreshadows the development of Monet's colour over the next decade, towards richer and more calculated harmonies. *Varengeville Church*, of 1882, shows that, even before his first Mediterranean trip of 1884 (see Plate 30), he had begun to recreate atmospheric effects in terms of rich colour compositions.

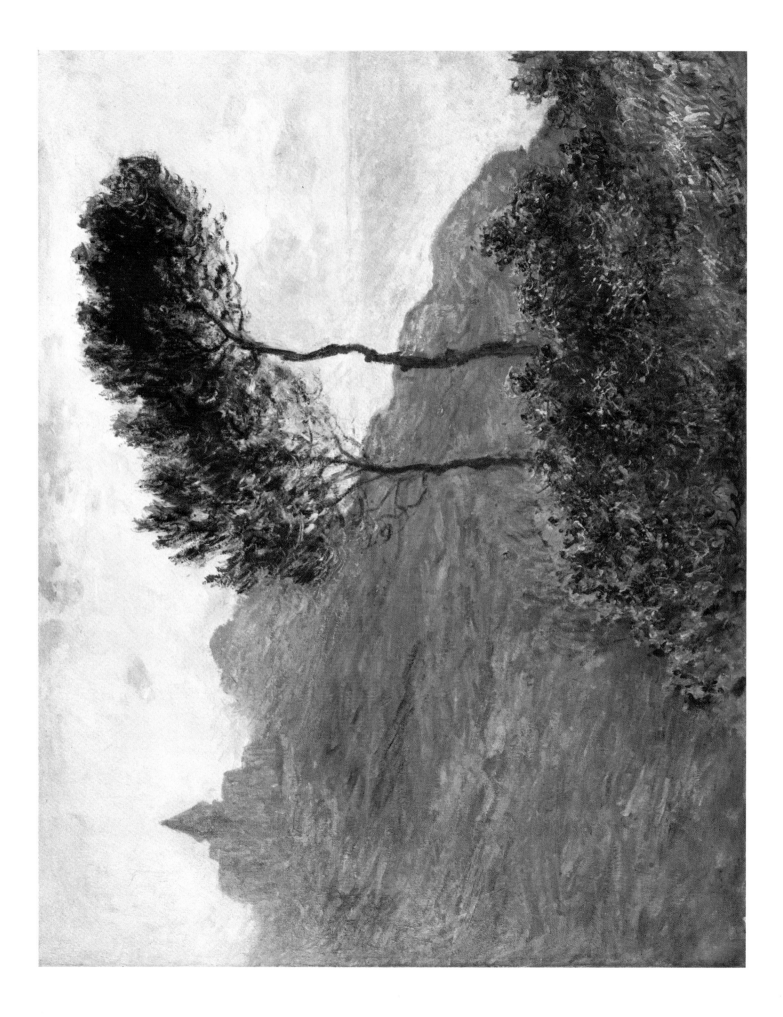

Bordighera

OIL ON CANVAS, 73 x 92 CM. 1884. SANTA BARBARA, CALIFORNIA, MUSEUM OF ART

Monet's trip to the south early in 1884 presented him with a new set of problems — of matching in paint the luminosity of the Mediterranean light. During his stay at Bordighera (just across the Italian border from Menton), he realized that this experience was forcing him to emphasize contrasts of blue and rose, as seen in *Bordighera*: here, the rich blues and pinks in the foreground enrich the local colours of the foliage, while the play of light and shade on the far mountains is suggested by more delicate blues and pinks alone.

The whole atmosphere is united in an overall coloured harmony, created by rhyming, interrelated hues.

At Bordighera, he was particularly attracted by the exotic sub-tropical foliage and trees. Sometimes these are the prime subject, sometimes they frame vistas of the old town and the sea (e.g. Fig. 35), and sometimes as in Plate 30, they are seen in the spacious streets of the new town — then becoming a fashionable winter resort.

Fig. 35 Bordighera

OIL ON CANVAS, 65 x 81 CM. 1884. THE ART INSTITUTE OF CHICAGO

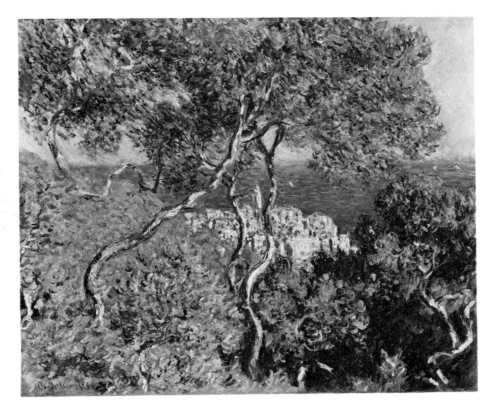

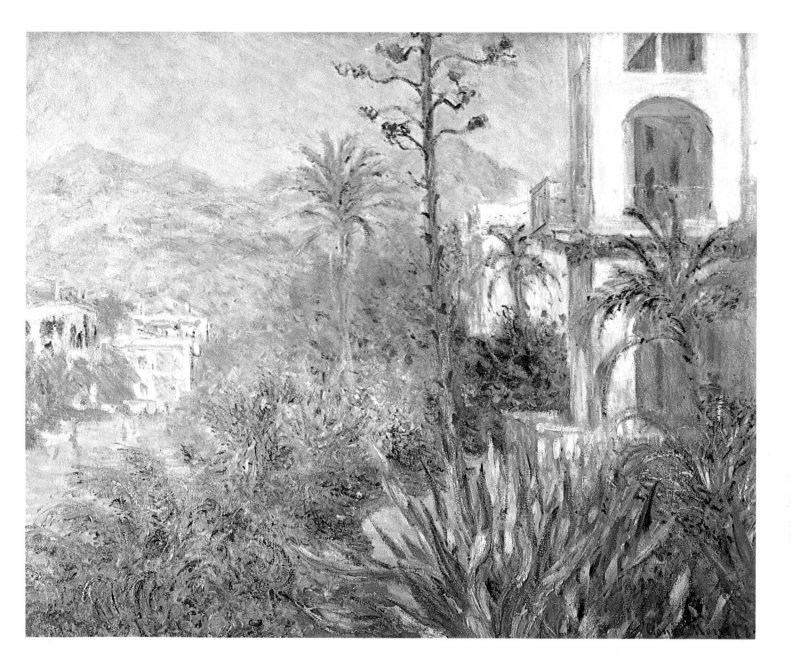

Spring

OIL ON CANVAS, 65 x 81 CM. 1886. CAMBRIDGE, FITZWILLIAM MUSEUM

Spring was painted in an orchard at Giverny, where Monet had settled with Alice Hoschedé and her children in 1883. Giverny is a village situated on a tributary of the Seine; wide water meadows lie between it and the Seine itself, creating a dominantly horizontal landscape, ringed by low hills and articulated by streams and banks of trees. Monet took some time to appreciate fully its pictorial qualities; he later praised the place for being 'not too picturesque — the motifs did not jump at you at once, but required seeking'.

His Giverny paintings of the 1880s respond to these qualities: they are quite unlike the dramatic subjects that he chose on his travels of the decade (see Plates 28–30, 32–4, 36); instead he focused on the meadows and river-banks, simple, horizontal subjects which echo his Seine valley themes from Argenteuil and Vétheuil of the 1870s. However, at Giverny his treatment of these themes became more elaborate, in the patterns of their brushwork and the harmonies of their colour. The richly woven surface of *Spring* may be contrasted with the simplicity of execution of *Summer, the Meadow* of 1874 (Plate 17).

The Pyramides at Port-Coton

OIL ON CANVAS, 66 x 66 CM. 1886. PRIVATE COLLECTION

In the autumn of 1886, Monet turned to a coastal scenery quite unlike Normandy or the Mediterranean — the granite island of Belle-Isle, off the south west coast of Brittany. Here, the sombre crags and needles stand out from the richly coloured waves of the Atlantic. Fascinated initially by this natural architecture, Monet was fired with greater enthusiasm when storms hit the island, despite the impossibility of representing them in anything more than rapid sketches. Such sketches (e.g. Fig. 36) show his technique at its most ebullient, in the sweeping calligraphic brushstrokes that he used to capture the surge of the sea. Even his more highly finished paintings of calmer effects, such as *The Pyramides at Port-Coton*, have a density of tone and a sobriety of mood quite unlike his previous work.

Monet's dealer Durand-Ruel was worried by the prospect of his sombre Belle-Isle paintings, when Monet was just beginning to win a reputation as a painter of sunlight. However, Monet insisted that he should not specialize in a single mood: 'I'm inspired by this sinister landscape, precisely because it is unlike what I am used to doing; I have to make a great effort, and find it very difficult to render this sombre and terrible sight.'

Fig. 36 Storm on Belle-Isle

OIL ON CANVAS, 60 x 73 CM. 1886. PRIVATE COLLECTION

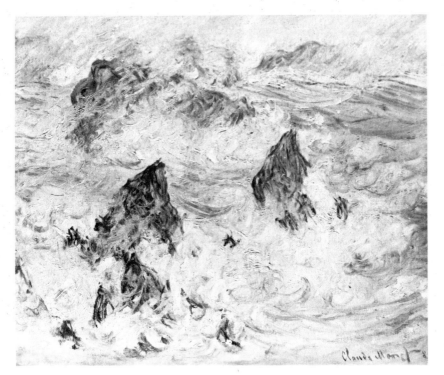

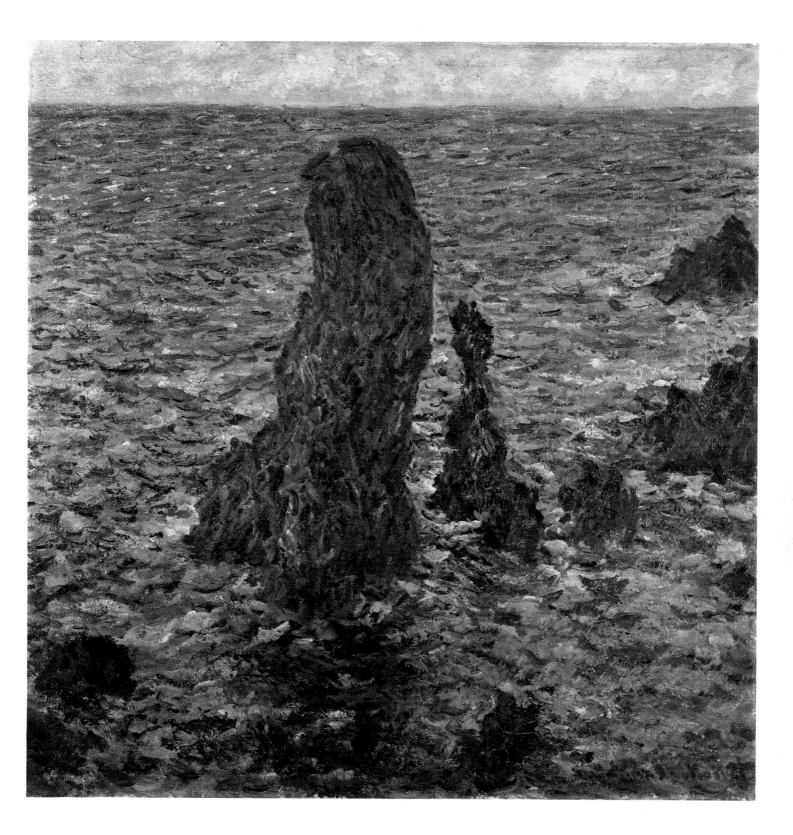

Antibes

OIL ON CANVAS, 65 x 92 CM. 1888. LONDON, COURTAULD INSTITUTE GALLERIES

When Monet visited Antibes early in 1888, he intended its tender mood and its atmosphere of blue, rose and gold to contrast with the savagery of his Belle-Isle paintings (see Plate 32). The Antibes canvases returned to the mood of the paintings from his first Mediterranean trip of 1884 (see Plate 30), and Monet interpreted the light in very similar ways. In *Antibes* the oppositions in the foreground of strong reds and oranges against greens and blues gives way in the distance to suffused pinks and blues. In 1888 an English interviewer described how Monet used colour to unify his paintings: 'One of his great points is to use the same colours on every part of the canvas. Thus the sky would be slashed with strokes of blue, lake, green and yellow, with a preponderance of blue; a green field would be worked with the same colours with a preponderance of green, while a piece of rock would be treated in the same way, with a preponderance of red. By working in this way, the same colour appearing all over the canvas, the subtle harmony of nature . . . is successfully obtained without the loss of colour.' The rhymes and interrelationships of colours in *Antibes* show how Monet put these ideas into practice. Its composition has clear parallels with Japanese prints (see Fig. 9, and note on Plate 29).

The Umbrella Pines, Antibes

OIL ON CANVAS, 73 x 92 CM. 1888. PRIVATE COLLECTION

Looking out to sea from the Cap d'Antibes, Monet used the pines as a continuous screen across *The Umbrella Pines, Antibes*; sea, land and sky are reduced to simple bands around them, leaving the eye to focus on the lines of the trunks and the textures of the foliage alone, in contrast to the active relationship between foreground and distance in *Antibes* (Plate 33). *The Umbrella Pines* in some ways anticipates the simpler compositions that Monet came to favour after 1890 (see Plates 37-40).

Monet exhibited ten of his Antibes paintings, probably including both Plates 33 and 34, at the branch of the Boussod & Valadon gallery, which was managed by Theo van Gogh, brother of Vincent. Vincent, living at Arles at the time, only heard of the show by letter. It was at this point, with the support of dealers such as Boussod & Valadon and Georges Petit, that Monet first gained real commercial and financial security.

Five Figures in a Field

OIL ON CANVAS, 79 x 79 CM. 1888. PRIVATE COLLECTION

Between 1886 and 1890, Monet experimented, for the last time in his career, with figure painting, wanting, as he told a friend, to paint 'figures in the open air as I understand them, treated like landscape. It's an old dream that always troubles me, and I want to realise it once and for all.' He undertook this experiment with the encouragement of his friends, among them Renoir, who was himself much pre-occupied with the problems of figure painting at the time. However, Monet treated his figures as a part of the land-scape which surrounded them, in contrast to Renoir's clas-sicizing compositions of nudes, such as his *Bathers*, com-pleted in 1887 (Philadelphia Museum of Art, Mr and Mrs Caroll S. Tyson Collection).

For his models, Monet used his own children and those of Alice Hoschedé, setting them in the watermeadows around Giverny, as in *Five Figures in a Field*, or in boats, as in *Girls in a Boat* (Fig. 37).

Fig. 37
Girls in a Boat

OIL ON CANVAS, 145 x 132 CM. 1887. TOKYO, NATIONAL MUSEUM OF WESTERN
ART

Valley of the Creuse at Fresselines

OIL ON CANVAS, 65 x 92 CM. 1889. BOSTON, MUSEUM OF FINE ARTS

In the early months of 1889, Monet painted in the valley of the Creuse, in the Massif Central. He meant these wintery rocky landscapes to echo the mood of his Belle-Isle paintings (see Plate 32), in contrast to his Antibes canvases of the previous year (see Plates 33 and 34). *Valley of the Creuse at Fresselines* is one of the brightest and most richly coloured of the Creuse pictures; it was presumably reworked to show the spring effects which burgeoned during Monet's last weeks in the place, in May.

The painting represents the meeting point of the two rivers, the Grande Creuse and the Petite Creuse, whose united waters flow through the ravine away from the spectator. Monet painted this subject nine times during his stay, and included five of these canvases in the major retrospective exhibition which Georges Petit mounted of his work in summer 1889. However, this sequence of paintings of one subject was presented in the context of the full variety of Monet's work, unlike the exhibitions of his mature series from 1891 onwards (see Plates 37 and following).

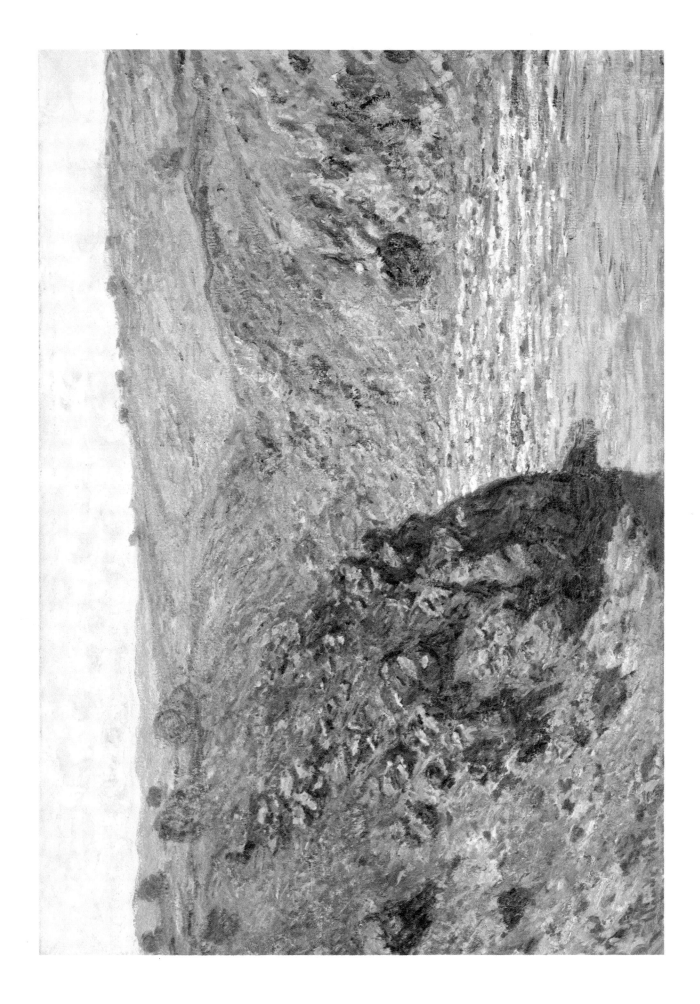

Haystacks, End of Summer

OIL ON CANVAS, 60 x 100 CM. 1890–1. PARIS, MUSÉE DU LOUVRE, JEU DE PAUME

In later years, Monet often told the story of the origin of the Haystacks series. In the late summer of 1890, he was painting haystacks in a field beside his house, and was beset by the rapidly changing atmospheric effects. Each time the light changed, he asked Blanche Hoschedé, who was helping him, to fetch him a new canvas. Thus, as the effects multiplied, so did his canvases. The idea of treating such shifting nuances had been in his mind for some years (see Plate 24), but only with the Haystacks did he feel able to make such variations into the principal theme of a whole series of paintings.

Haystacks, End of Summer was begun in 1890, but Monet gave the canvas the date '91' when he exhibited it with the rest of the Haystacks series (see Plates 38 and 39) at Durand-Ruel's gallery in May 1891. This dating, and the painting's encrusted paint surface, suggest that Monet reworked it in the studio prior to the exhibition. The homogeneity of the surface marks a turn away from the dynamic handling that Monet had used to convey his more dramatic subjects of the 1880s. As he focused more on the unity given to a scene by its atmosphere, he evolved a correspondingly unified type of paint surface.

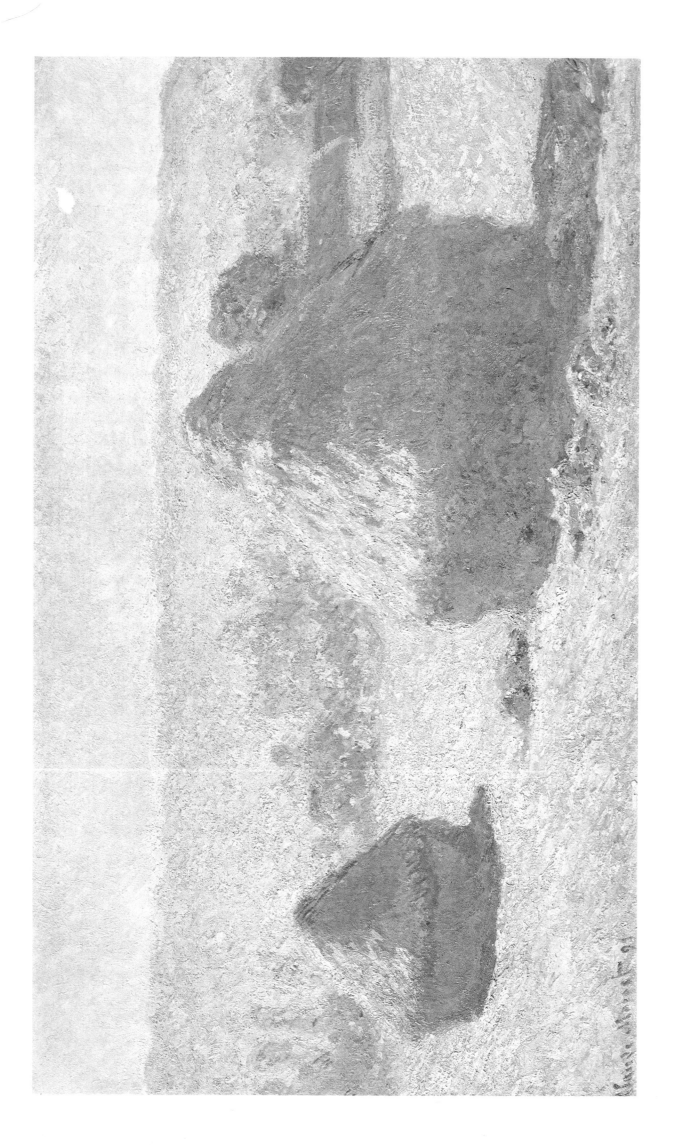

Haystack at Sunset, Frosty Weather

OIL ON CANVAS, 65 x 92 CM. 1891. PRIVATE COLLECTION

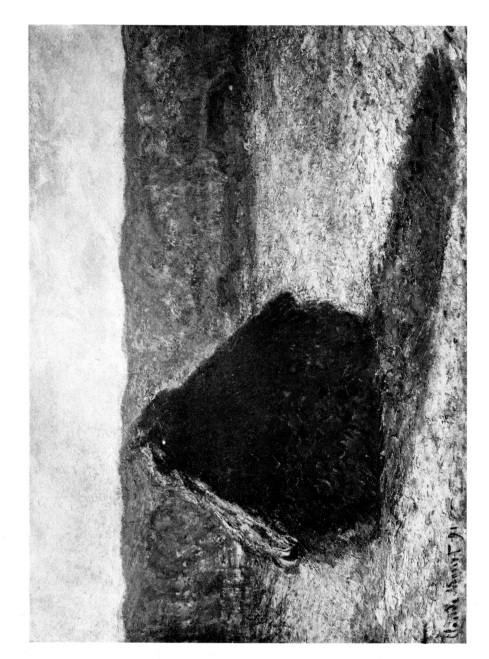

After beginning a series of paintings of Haystacks late in the summer of 1890 (see Plate 37), Monet returned to the theme in December 1890 and January 1891, when a protracted cold spell allowed him to execute a major group of paintings of snow and frost effects. In them he could focus exclusively on the rich colours of sunlight, shadow and atmosphere, since the local colours of the scene were masked by the covering of snow. Often, as in *Haystack at Sunset*, Monet picked the most fleeting natural effect; but out of these effects he felt the need to produce a fully finished painting. Since his natural subjects passed too rapidly for him to finish his canvases out of doors in front of them, he was paradoxically forced to elaborate his initial notations of these transitory moments at his leisure in the studio. *Haystack at Sunset* is one of the most lavish of the series; its colour scheme was greatly elaborated during its execution, probably in the studio, by the addition of a sequence of rich and varied pinks, oranges and blues, so that the final result is more an elaborate improvisation than a directly observed natural effect. *Haystack, Snow Effect, Morning* shows the same haystack at a different time of day (Fig. 38).

Fig. 38 (right)

Haystack, Snow Effect, Morning

OIL ON CANVAS, 65 x 92 CM. 1891. BOSTON, MUSEUM OF FINE ARTS, GIFT OF
MISSES AIMEE AND ROSAMUND LAMB IN MEMORY OF MR AND MRS HORATIO A LAMB

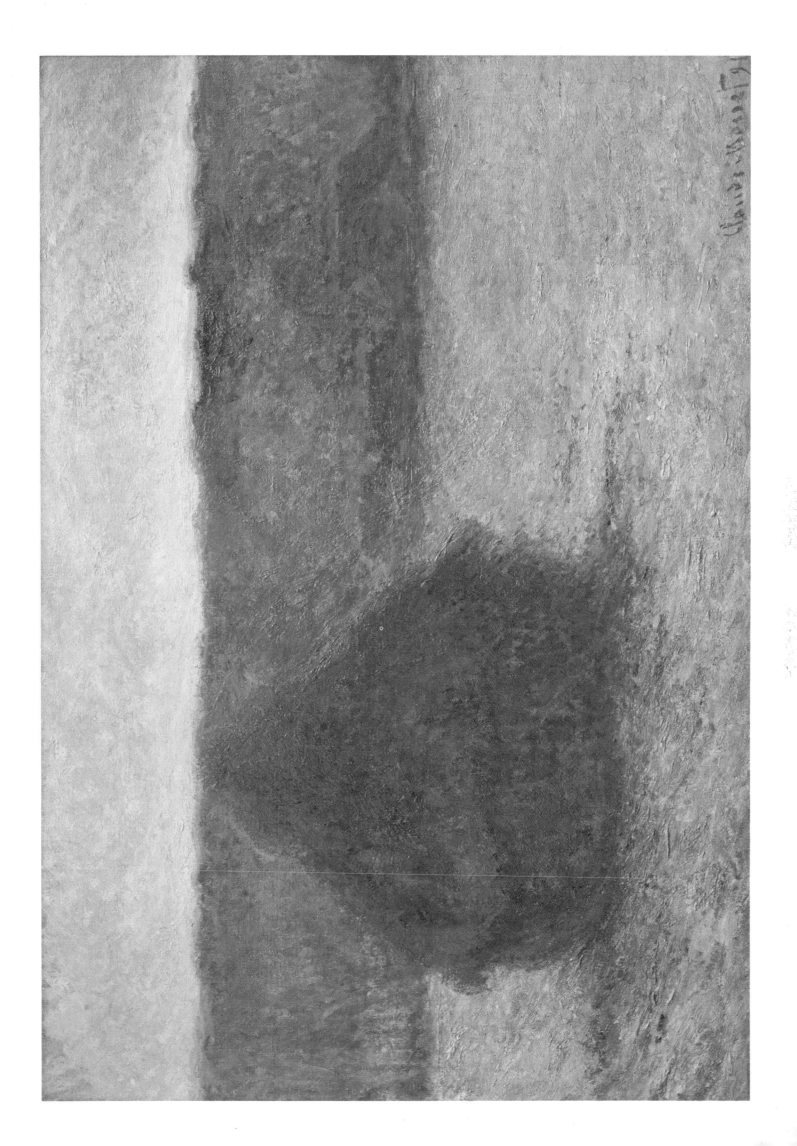

Haystack in Sunlight

OIL ON CANVAS, 60 x 100 CM. 1891. ZURICH, KUNSTHAUS

Haystack in Sunlight may well have been one of the fifteen canvases of Haystacks which Monet exhibited at Durand-Ruel's gallery in May 1891; Plates 37 and 38, and Fig. 38, were definitely shown. The exhibition was a new departure for Monet in a number of ways. It marked the end of his decade of travels, and a move away from the picturesque and dramatic subjects that he had favoured during his journeys towards the monumental, simple forms of haystacks in an open field. With this exhibition, too, the unity of the whole ensemble became paramount; though Monet included a few other canvases in it, the Haystack paintings were presented as a unified sequence, a set of variations on a single theme. Their colour and atmospheric effects vary, as do the groupings of haystacks shown, but their overall theme, and the type of composition made of them, are very homogeneous, in contrast to the diversity of sites and moods that Monet had included in his previous exhibitions.

Haystack in Sunlight, in its composition one of the most experimental and arresting of the Haystacks series, is probably the canvas that Wassily Kandinsky saw at an exhibition in Moscow in 1896–7. He did not at once recognize it as an image of a haystack, and this moment of non-recognition, he later recalled in his *Reminiscences,* revealed to him 'the unsuspected power of the palette, . . . which surpassed all my dreams. . . .And unconsciously the object was discredited as an indispensable element of a painting.'

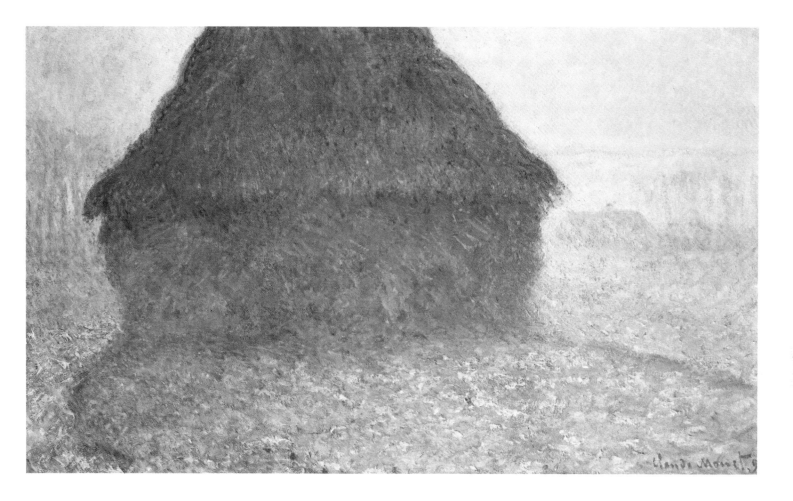

The Poplars, the Three Trees, Autumn

OIL ON CANVAS, 92 x 73 CM. 1891. PHILADELPHIA MUSEUM OF ART, CHESTER DALE COLLECTION

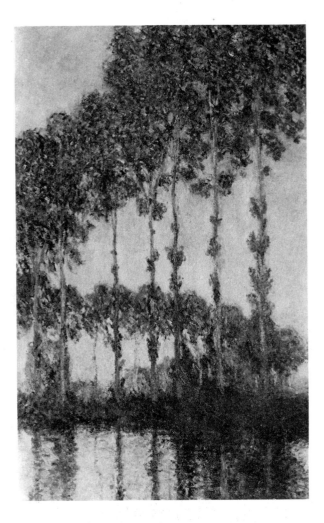

In the summer of 1891 Monet learned that a row of poplars on the river Epte near Giverny were to be felled and paid their purchaser to leave them standing for long enough for him to paint them. He worked out of doors on the Poplars into the autumn and exhibited fifteen paintings of Poplars as a series at Durand-Ruel's gallery in February 1892, presumably after elaborating and finishing them in his studio (see Plate 38). No pictures of other subjects were included in this exhibition, but, as with the Haystacks (Plates 37–9), Monet painted the trees from varied viewpoints: sometimes, the nearer row is seen from close by, and, with their reflections, they make a grid running the full height of the canvas, as in Plate 40; sometimes, Monet included the crowns of the nearer trees to create a continuous zig-zag of trees leading back into space, as in Fig. 39. Whereas the Haystack paintings had focused on simple masses, the Poplars are a filigree of trunks and foliage; but both series translate atmospheric variations into rich colour harmonies.

Fig. 39 (left)
Poplars on the Epte, Sunset

OIL ON CANVAS, 100 x 65 CM. 1891. PRIVATE COLLECTION

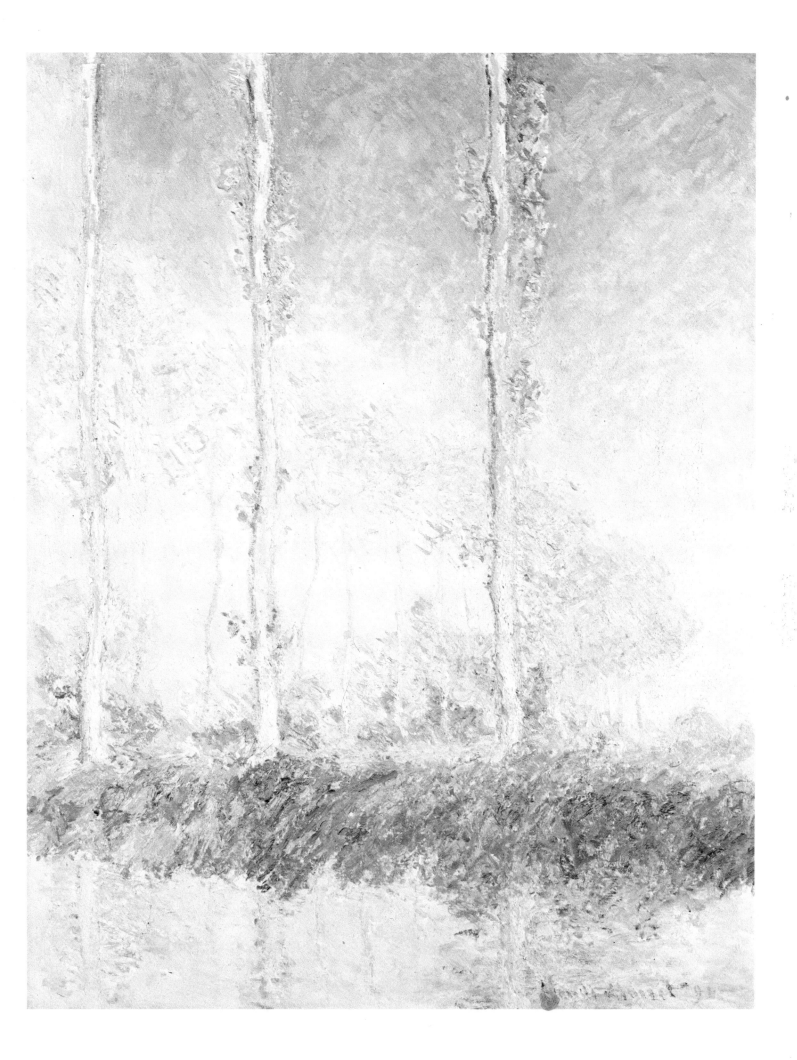

Rouen Cathedral, the Portal, Morning Effect

OIL ON CANVAS, 100 x 65 CM. 1893–4. ESSEN, FOLKWANG MUSEUM

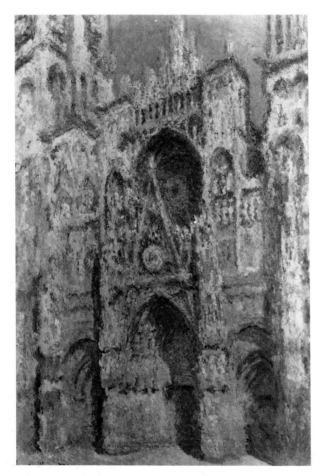

In May 1895 Monet exhibited twenty canvases of Rouen Cathedral, eighteen of them (including Plate 41 and Fig. 40) showing its west facade. The series was begun during two long spells of work at Rouen in the early months of 1892 and 1893, but much had to be done to the paintings in the studio at Giverny before Monet felt willing to exhibit them. The densely impasted, encrusted surfaces of most of the canvases bear witness to this protracted process of reworking.

The stone facade of the Cathedral — itself largely colourless — presented Monet with a great challenge, since he had no array of natural colours as his starting point. In 1895 Monet told an interviewer that he wanted to paint not objects themselves, but the atmosphere that lay between him and them, and in the Rouen Cathedral paintings the atmospheric variations on the static stone screen are the prime focus. He used the facade as the theme for an elaborate set of colour variations which evoke the varied angles of lighting that played on the facade and the delicate mists that veiled it.

Fig. 40 (left)
Rouen Cathedral, the Portal and the Tour d'Albane, in the Sunlight

OIL ON CANVAS, 107 x 73 CM. 1893–4. PARIS, MUSÉE LOUVRE, JEU DE PAUME

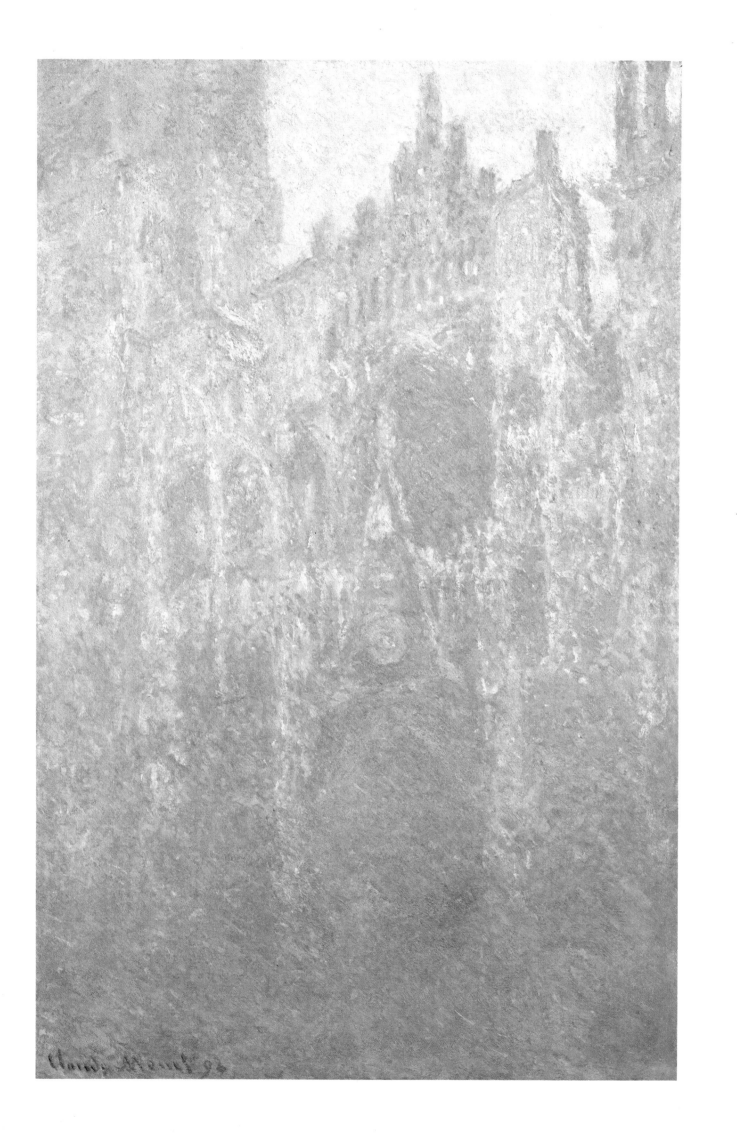

Morning Mists

OIL ON CANVAS, 89 x 92 CM. 1897. PRIVATE COLLECTION

Morning Mists is part of a series exhibited with the title *Early Mornings on the Seine* at Georges Petit's Gallery in June 1898; Monet worked on them out of doors during the summers of 1896 and 1897. He chose to paint this subject at dawn, he said, because 'it was an easier subject and simpler lighting than usual', and therefore he was able to take the pictures further. However, even with this series, it seems likely that the studio played a significant part in the final organization of their colour-schemes.

In the *Early Mornings*, Monet returned to his favourite motif of a subject seen across water (see Plates 9, 16, 23). Here, the equation between trees and reflections is even closer than in the earlier paintings, and gives a strong two-dimensionality to the patterns of forms across the canvas. Distance is conveyed by the delicate, luminous hues of the furthest trees and the sky. The early morning effect, with its diffused lighting, has clear affinities with Corot. The Impressionists had earlier criticized Corot for executing his finished pictures in the studio, but by the 1890s Monet had become a great enthusiast for Corot's harmonious vision of nature. The mood of the *Early Mornings* is particularly close to Corot's famous *Souvenir of Mortefontaine* of 1864 (Fig. 41).

Fig. 41 **J.B.C. Corot** (1796–1875): Souvenir of Mortefontaine

OIL ON CANVAS, 65 x 89 CM. 1864. PARIS, MUSÉE DU LOUVRE

The Lily Pond

OIL ON CANVAS, 89 x 93 CM. 1899. LONDON, NATIONAL GALLERY

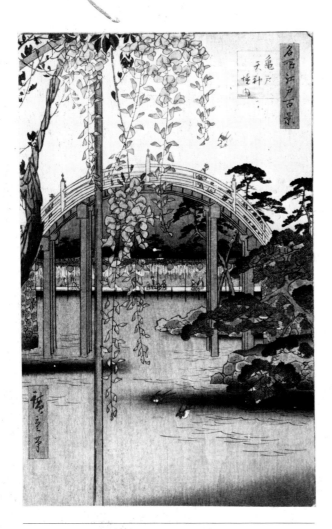

In 1893 Monet bought a stretch of land by a small river below his house at Giverny, and during the following years progressively constructed an elaborate water garden (see Fig. 11). He had always been a keen gardener, and had often painted the gardens of his previous homes. However, in his water garden he was finally able to design for himself a complete natural environment, a ready made outdoor subject, which grew and flowered to his specifications.

The garden developed gradually. At first, he said, 'I planted my water-lilies for pleasure; I cultivated them without thinking of painting them. A landscape does not get through to you all at once. And then, suddenly, I had the revelation of the magic of my pond'. Plates 43 and 44 belong to his first series of the water garden, painted in the summers of 1899 and 1900, and exhibited at the end of 1900. They show the pond in its original state, extending only about 20 metres beyond the foot-bridge. In its form in these paintings, the pond has a close resemblance to a Japanese example, Hiroshige's *Wistaria at Drum Bridge* (Fig. 42); moreover, the general principles that he used in designing the garden, irregularly contoured and exploiting the natural resources of the region, are close to those of the makers of traditional Japanese gardens, themselves an important branch of Japanese artistic creation.

Fig. 42
Hiroshige (1797–1853):
Wistaria at Drum Bridge

FROM 'A HUNDRED FAMOUS PLACES IN YEDO'. WOODBLOCK PRINT

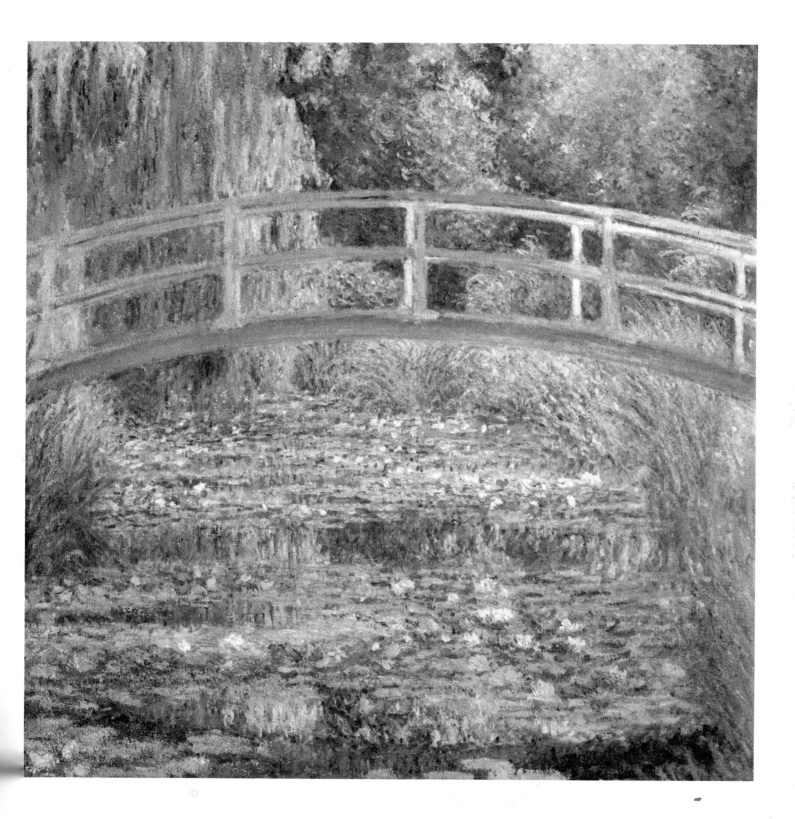

Japanese Footbridge

OIL ON CANVAS, 89 x 93 CM. 1899. PHILADELPHIA MUSEUM OF ART

The Japanese Footbridge and *The Lily Pond* (Plate 43), from the twelve water garden canvases exhibited in 1900, show how closely related the individual canvases in Monet's series could be. They are very similar in colour scheme and overall organisation, differences appearing only in the details of their lighting and arrangement. Other canvases from this series are rather more varied, but the whole group was very closely related.

After the completion of this first series, Monet completely reconstructed his garden and greatly enlarged the pond, widening and lengthening it so that it finally extended about 60 metres from the bridge (see Fig. 11). If the first excavations had been made without a thought of painting there (see Plate 43), the enlargements were designed expressly with painting in mind: Monet spent the summers between 1903 and 1908 painting the pond, and exhibited forty-eight canvases of it in 1909, after a protracted struggle to finish the paintings to his satisfaction. The earliest canvases of the second water-lily series retain a horizon, a narrow band of the pond-bank above the expanse of water; but from 1905 onwards (see Fig. 43) Monet omitted this, giving over the whole canvas to the water surface, with its lily pads and reflections. The constant variations of light and air across this surface were the subject of the series.

Fig. 43 Water-Lilies

OIL ON CANVAS, 90 x 100 CM. 1905. BOSTON, MUSEUM OF FINE ARTS, GIFT OF EDWARD J. HOLMES

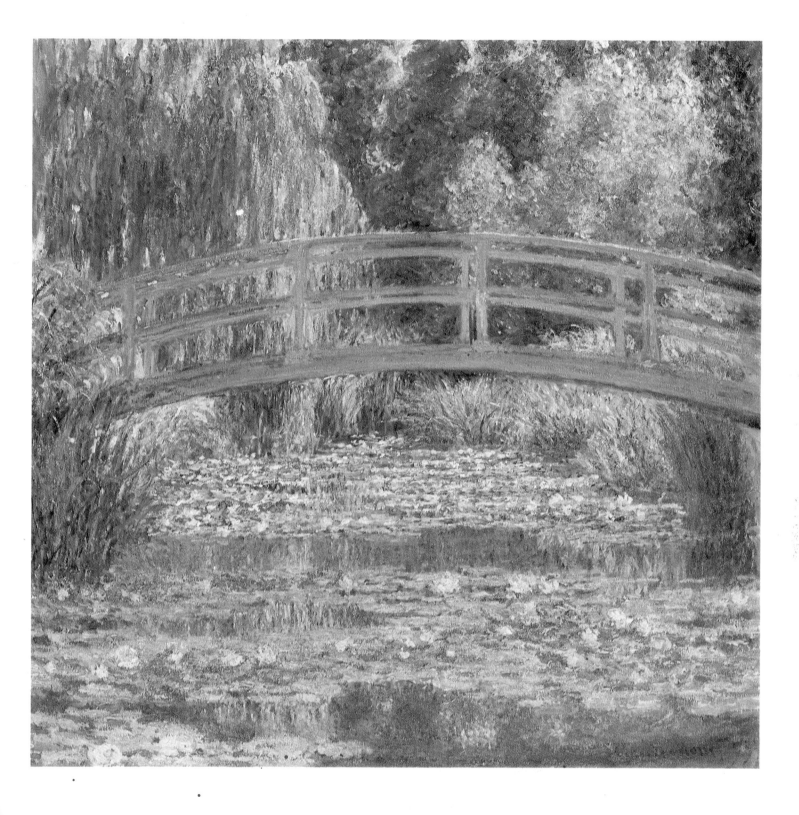

Waterloo Bridge

OIL ON CANVAS, 65 x 100 CM. C.1900-3. PITTSBURGH, CARNEGIE INSTITUTE

Monet paid three winter visits to London to paint between 1899 and 1901. Staying in the Savoy Hotel, he painted two of his subjects from the balcony of his room overlooking the Thames, looking south towards the Houses of Parliament, and looking east across Waterloo Bridge, as in Plate 45; he also undertook a third motif, of the Houses of Parliament seen from St Thomas's Hospital, as in Fig. 44. After many delays he mounted an exhibition in 1904 of thirty-seven paintings of these three subjects, selected from the very much larger number of canvases which he had begun in London.

For Monet, the great appeal of London was its fogs, its effects of almost tangible atmosphere. He had first painted mists in London in 1870–1 (see Plate 11) and had planned to return to paint the Thames during the intervening years, encouraged perhaps by the example of Whistler, who became a good friend during the 1880s. Whistler had revolutionized accepted views of the potential of London as an artistic subject by his Thames *Nocturnes* (see Fig. 22), and by the 1890s a vision of London veiled in its winter fogs was an artistic commonplace. However, in an important respect Monet's vision of London was very different from that of his contemporaries — in his use of colour: whereas they followed Whistler's subdued and essentially tonal vision, Monet's mists are suffused with delicate yet endlessly varied harmonies of colour, as in his previous series (see Plates 38 and 41).

Fig. 44
The Houses of Parliament

OIL ON CANVAS, 81 x 92 CM. C.1901-4. PARIS, MUSÉE DU LOUVRE, JEU DE PAUME

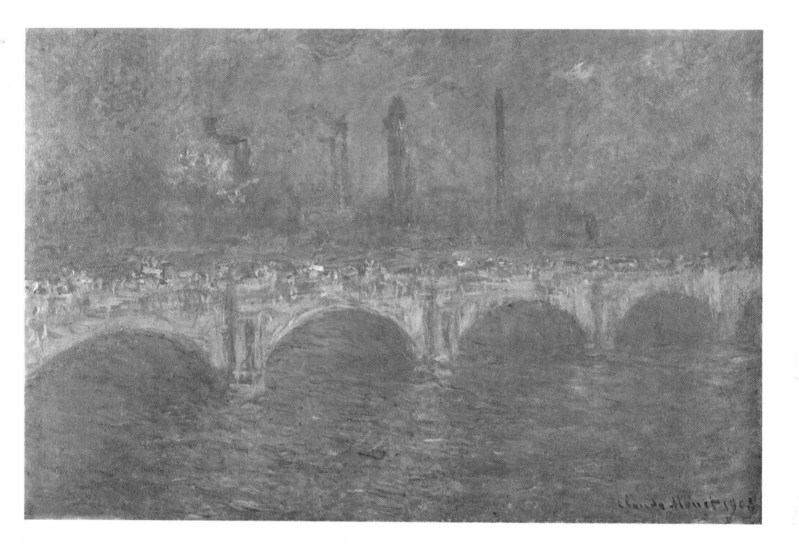

Water-Lilies

OIL ON CANVAS, 200 x 425 CM. C.1916–22. LONDON, NATIONAL GALLERY

In 1916, Monet began to paint his water garden (see Plates 43 and 44) on a vast scale, in a sequence of canvases two metres high and up to six metres long, envisaged as a decoration for a circular or oval room. He had for many years had the idea of making the water-lily theme into a decorative scheme, but only in 1914 did his friend the statesman Clemenceau persuade him that he was not too old to undertake such an enormous project. By 1916, despite the war, a vast specially constructed studio was complete (see Fig. 46): from the start, Monet realized that he would not be able to paint on this scale out of doors, and executed the full-size canvases in the new studio, basing them on a synthesis of memory and smaller canvases painted out of doors — a return, in essence, to his procedures in painting his first canvases for the Salon (see Plates 1 and 2; also Plates 25 and 26). Fig. 45 is an example of the smaller water-lily paintings that supplied him with his raw material.

After long debate about their final destination, it was settled in 1922 that the Government should build two oval halls for them on the lower floor of the Orangerie in Paris. The paintings were finally installed in these after Monet's death, and opened to the public in 1927 (see Fig. 12). Monet had painted many more canvases of two metres high than could be accomodated in the Orangerie; these, sold by his son during the 1950s, have entered many museums in Europe and America (e.g. Plates 46 and 47).

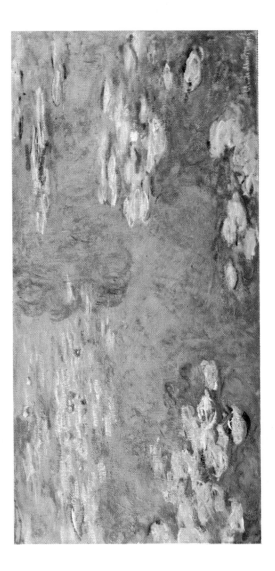

Fig. 45
Water-Lilies

OIL ON CANVAS, 100 x 200 CM. 1919. PARIS, PRIVATE COLLECTION

OIL ON CANVAS, 200 x 426 CM. C.1916–22. CLEVELAND, MUSEUM OF ART

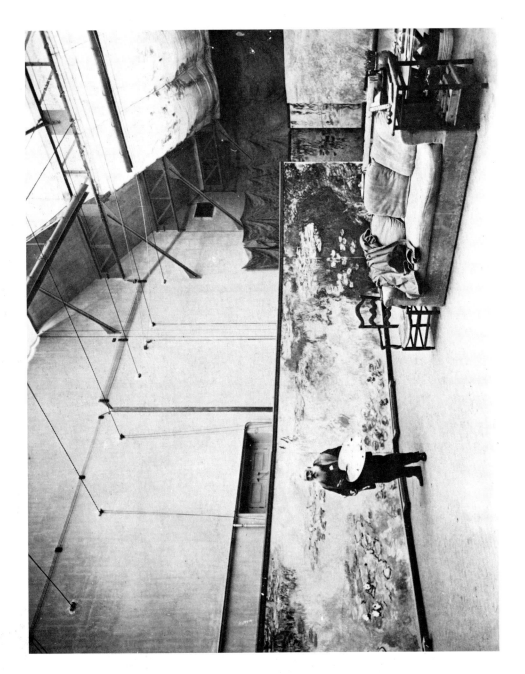

Like Plate 46, this is one of the two metre high canvases that Monet did not choose for the installation of the water-lily decorations in the Orangerie in Paris. As he worked up his compositions, he experimented with various groupings of canvases, with a view to creating long continuous sequences along a wall, such as those on the longest sections of the Orangerie rooms (see Figs. 12 and 46). Plate 47 has been shown to be the left part of a triptych of canvases, now disbanded; the other two are in the museums of St Louis and Kansas City. Together they would have formed a sequence almos: 13 metres long.

This triptych, like parts of the first room at the Orangerie, is devoted entirely to the water surface, without the intrusion of any surrounding foliage — an extension of the compositions of other series of 1905–8 (see Fig. 43). Their compositions are made up entirely by sequences of freely floating lily-pads, set off against the changing colours, tones and textures of the reflections in the areas of open water. In the inner room at the Orangerie, by contrast, the decorations are framed and punctuated by the trunks and hanging foliage of weeping willows, which give them a tauter formal structure (see Fig. 12). In some of the large canvases, such as Plates 46 and 47, the reflections are soft, without clearly defined forms. However, in the most highly finished of them, notably the Orangerie decorations, the patterns of reflected trees and clouds are more explicit; they create an elaborate counterpoint between the space felt as the eye moves up across the water surface, and the distant space seen in the reflections — the trees and sky above and beyond the pond.

Fig. 46 (right)
Photograph of Monet in his Studio c.1920 Working on the Water-Lily Decorations

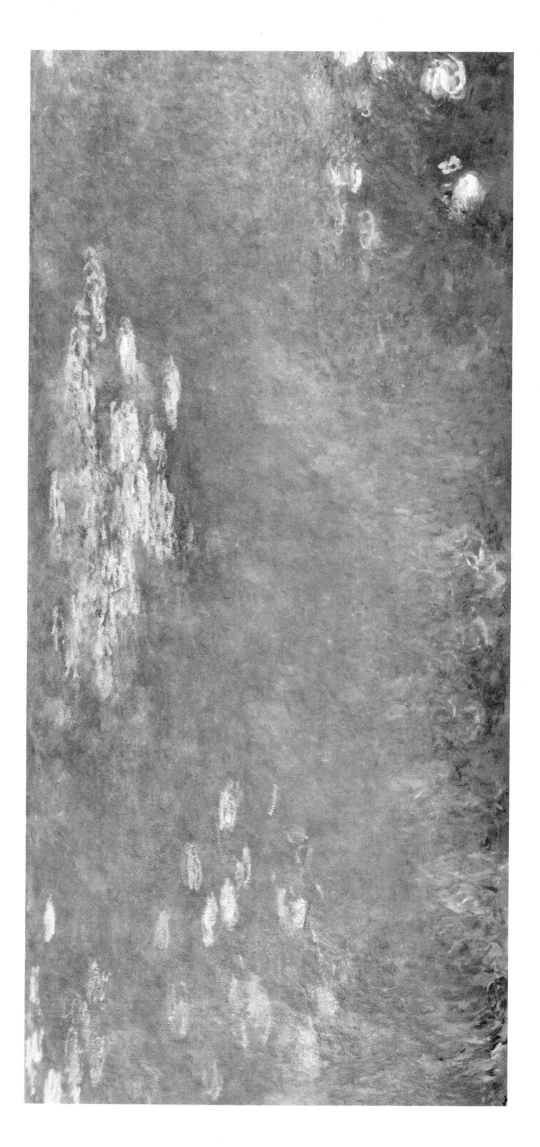

Detail of 'Water-Lilies' (Plate 46)

During the years which he devoted to them, Monet rework-ed his large Water-Lily canvases (see Plates 46 and 47) many times. The most thickly worked canvases, including most of those in the Orangerie in Paris, have densely en-crusted surfaces, which testify to extensive changes of plan, as well as elaboration of his initial ideas. Even less densely worked surfaces such as the detail shown in Plate 48 reveal alterations: here, there are clear signs of a dominantly blue layer below the soft oranges and mauves of the present paint surface.

The detail shows an area whose actual size is about 170 x 125 cms. It reveals the extraordinary freedom of Monet's late brushwork. The lily-pads are defined by fluent curls of the brush across the paint surface, while soft dashes and sweeps of fluid colour create nuanced veils across the open water surface, added over denser layers of impasto. In the decora-tions, Monet succeeded in enlarging the gestures of his brush to match the enlargement of his actual canvases, so that the individual strokes retain the active role within the ensemble that they had played in his earlier easel pictures (e.g. such canvases as Fig. 36, in particular). In 1866, he had failed to achieve a comparable enlargement of scale in his *Déjeuner sur l'herbe* (see Plate 2), but, half a century later, his accumu-lated experience of treating nature's effects at their most varied and extreme allowed him to transpose his vision onto this huge scale without losing any of its vitality.

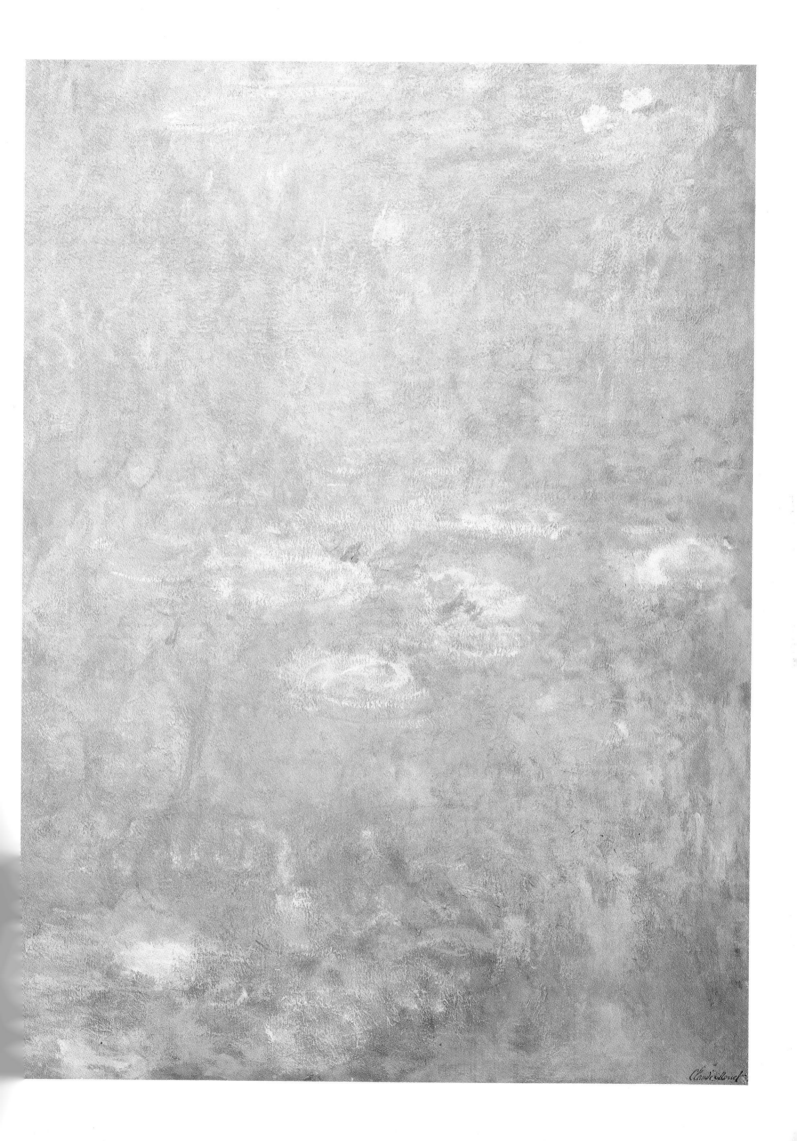